STOCKTON-ON-TEES
THROUGH TIME
Robin Cook

AMBERLEY PUBLISHING

First published 2014

Amberley Publishing
The Hill, Stroud, Gloucestershire, GL5 4EP
www.amberley-books.com

Copyright © Robin Cook, 2014

The right of Robin Cook to be identified as the Author
of this work has been asserted in accordance with the
Copyrights, Designs and Patents Act 1988.

ISBN 978 1 4456 3586 6 (print)
ISBN 978 1 4456 3602 3 (ebook)

British Library Cataloguing in Publication Data.
A catalogue record for this book is available from the
British Library.

Typesetting by Amberley Publishing.
Printed in Great Britain.

Introduction

Unlike some of the other towns in the Teesside area, Stockton-on-Tees has an ancient history, and was a favoured residence of visiting Bishops of Durham as far back as the early fourteenth century. A charter for a market and fair was granted in 1310, and renewed in 1602 and 1666. The River Tees has been an important factor in the development of the town, particularly as sea trading expanded over the centuries. The castle, standing above the riverbank, was rebuilt in 1316 but eventually totally destroyed in 1652. Pirate activities in the North Sea (the 'German Ocean') affected Tees shipping in the seventeenth century, at a time when the town evidently looked far from affluent. The first custom house for sea trading was established in 1681, and the benefaction of the first almshouses dates from 1682. The parish church opened in 1712, and the town hall was built in 1735.

Very serious flooding affected Yarm in 1752, 1761 and 1771. The original Stockton bridge was completed in 1771 at a cost of £8,000. In 1784, the Tees froze over, and a sheep was roasted on the ice at Portrack, the ice being 8.5 inches thick. Similar icing over of the river occurred in 1795 and 1814. In 1785, a violent storm caused great loss of life off the Tees mouth, and thirty-three vessels were shipwrecked. In 1795, there were forty-seven ships registered and operating from Stockton; this number grew to seventy-four by 1829.

In 1796, the Revd John Brewster wrote and published the first scholarly history of Stockton. A second, fuller edition, appeared in 1829. The last bull baiting in the town occurred in 1800. The first mail coach was established in 1806, and a press gang arrived from Sunderland in 1813, but there had been earlier such incidents in the previous century. The first steam mill was constructed in 1819 and in 1822 the first town gasworks was built for street illumination.

In 1810 and 1831, major improvements to River Tees navigation were achieved by cuts through the banks of the natural river course that shortened the distance between the Tees mouth and Stockton Quayside considerably. On 27 September 1825, the Stockton & Darlington Railway opened, the first passenger-carrying steam railway in the world, carrying 450 passengers and 90 tons of freight on its first journey. On occasion, it reached a frightening speed of 15 mph, leading to the first Durham coal being shipped from Stockton Quay in early 1826. By 1837, more than 150,000 tons of coal per annum were being exported from Stockton (1,681,000 tons by 1842) and 126 ships were based at the port; this number had grown to 272 by 1840. This coal exporting success let to the creation of the port of Middlesbrough for the same purpose. The population of Stockton had grown from a total of 1,820 in 1725 to 10,172 in 1851.

These interesting markers in the development of the town confirm a dynamic and positive outlook by the community leaders of the day, and the population more generally. The wide and historically elegant High Street was, from documentary evidence, largely in place as early as 1760. Over the centuries, trading via the river included flax imports and exports of sail cloth, wheat, butter, cheese and lead, as well as the later coal, shipbuilding, iron, steel, engineering and railway commerce.

The town and its leaders showed their ability in the past to adapt to the changing world, and to seize the opportunities that presented themselves. Let us hope that a similar capability emerges again after all the disappointments of the past fifty years or so.

My ability to put this collection of postcards and photographs together owes much to a number of people. I was greatly helped in my early local history of Stockton by Mark Rowland-Jones, then of the Museum Service; Joyce Chesney, now retired, led the Reference Library staff, and David Wilson's fascinating second-hand bookshop in Green Dragon Yard was an Aladdin's Cave of local material on occasions.

This volume has been given greater quality by the generous loan of some material from two of my postcard-collector friends, John Armstrong and Peter Fletcher. My contemporary photography has been enhanced by Peter Dobing, and my text recorded appropriately for publication by Joan Seymour, two more good friends, whose help to me in this field has extended over many years.

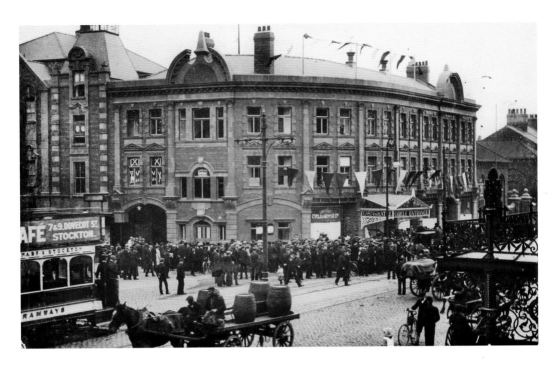

The Castle Theatre, High Street

Named after the former site of Stockton Castle, the theatre opened in 1908. This postcard view was taken in the early weeks after its completion, and the sender describes it as 'a grand building'. It was soon to be renamed the Empire Theatre, and was eventually demolished in 1969. The Swallow Hotel was then built on the site, but has now sadly stood empty since 2009. The early view includes various aspects of everyday life in the town.

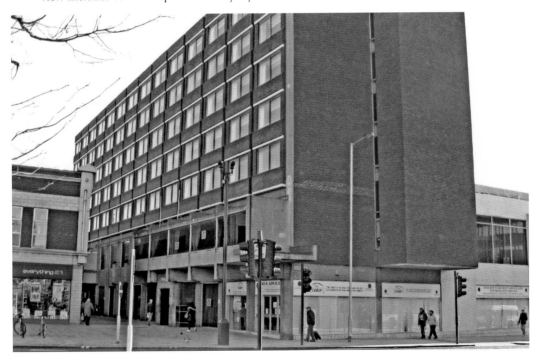

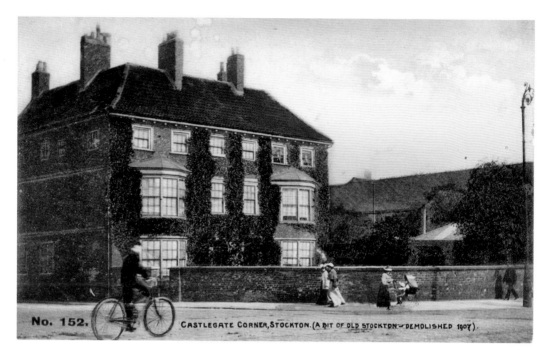

No. 152. CASTLEGATE CORNER, STOCKTON. (A BIT OF OLD STOCKTON — DEMOLISHED 1907).

High Street Views

A Brittain & Wright of Stockton postcard showing two early town houses, built in the second half of the seventeenth century, which were demolished in 1907 when the Castle Theatre was built on the same site at the south end of the High Street. The other postcard view shows some interesting forms of transport from the late 1920s, looking north with the Empire Theatre on the right. The trams ceased to operate in 1931.

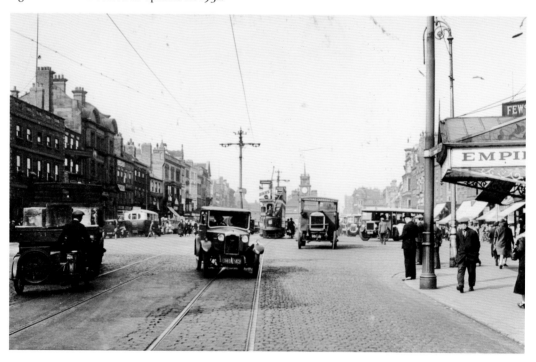

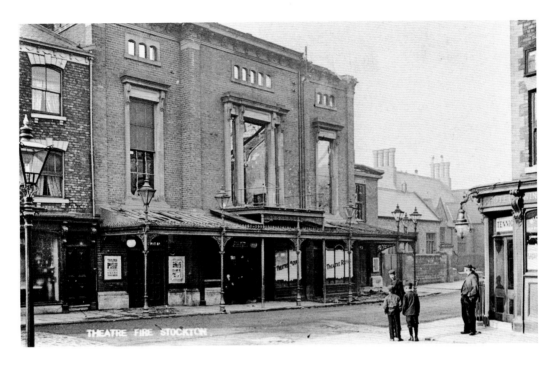

Theatre Fire, Yarm Lane

The Theatre Royal opened in 1866 on Yarm Lane, near to the High Street, but was sadly destroyed by a major fire on 28 August 1906. A roller-skating rink was then built on the site, and in the 1920s the venue became the famous Maison de Danse. This was eventually demolished in 1969. The Holy Trinity Boys School can just be seen beyond the theatre. It was associated with the adjacent church of the same title, situated in grounds some distance behind the theatre building. Here we see some of the well-behaved young boys in school uniform with their teacher.

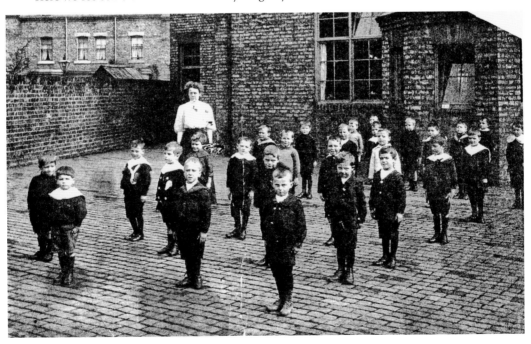

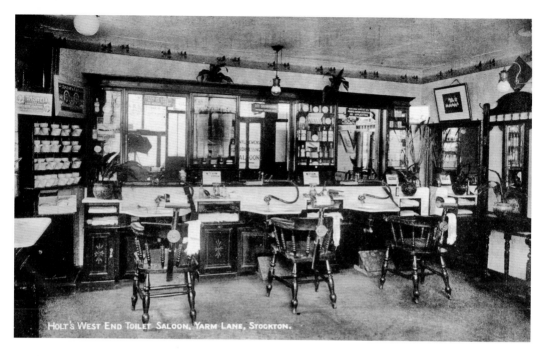

HOLT'S WEST END TOILET SALOON, YARM LANE, STOCKTON.

Local Businesses, Yarm Lane

Arthur Holt's West End Toilet Saloon was at No. 24 Yarm Lane, on the corner of West Row. This advertising postcard carries a portrait of the proud proprietor on the back with a printed message: 'Dear Sir, I have refitted my Saloon with the latest antiseptic improvements, and with a view to personal comfort, and solicit a continuance of your patronage.' The Olde Green Bushes Inn was at No. 54 Yarm Lane, at the junction with Brunswick Street, but was later replaced by the much taller, more imposing building still there today.

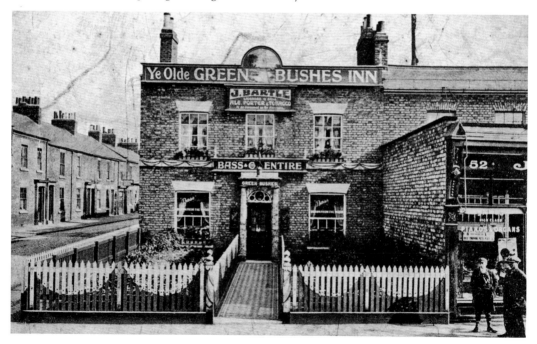

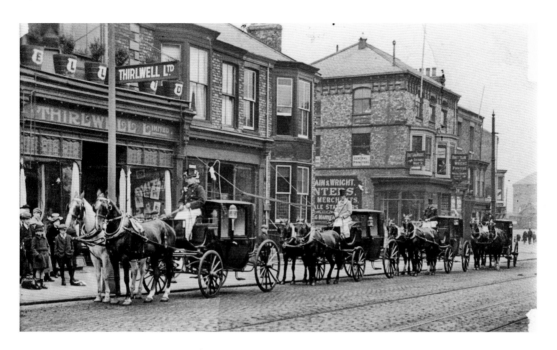

Wedding Procession, Bridge Road

A fine advertising postcard shows a wedding procession in Bridge Road around 1910. The wedding party have entered the famous Thirlwell's Studio for the official photographs to be taken. The Wharf Street premises of Brittain & Wright, postcard manufacturers, stand behind the rear carriages. The caption on the postcard reads, 'If you require a taxi or carriage for wedding or pleasure party, ring up Fred Walton, Black Lion Livery Stables, who is sure to please.' Today's view here is very unattractive, but across the road opposite is the Thomas Sheraton public house, formerly the County Court building.

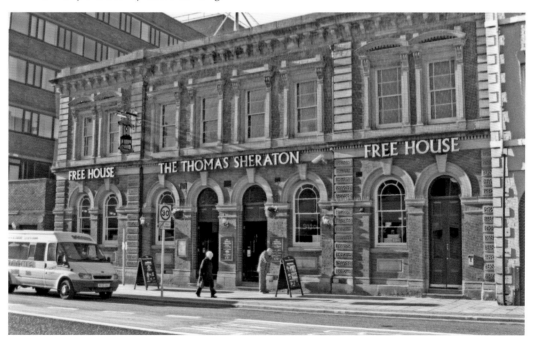

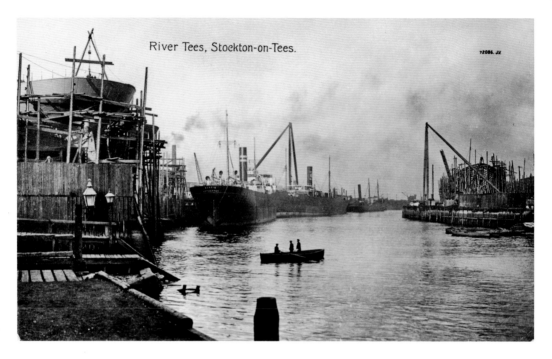

River Tees, Stockton-on-Tees.

72086. JV.

Shipbuilding on the River Tees

A busy scene from 1916 shows some of the Stockton and Thornaby shipyards, and illustrates the size of shipping occupying the quaysides at that time. Ropner's yard is on the left, and Blair's Marine Engineering Works lies in the centre, with its tripod lifting gear for moving engines into new vessels. The yard on the right is that of Craig Taylor in Thornaby. The peaceful contrast of today is quite amazing, with Teesquay Millenium footbridge linking the shopping centre to the business park and university quarter.

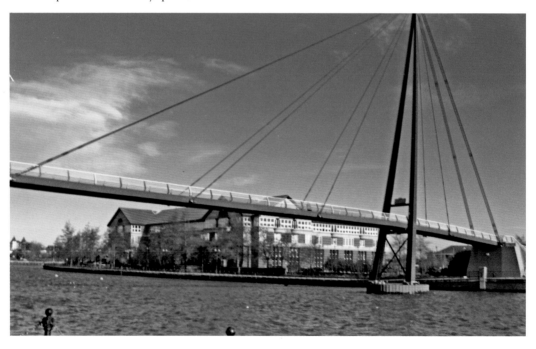

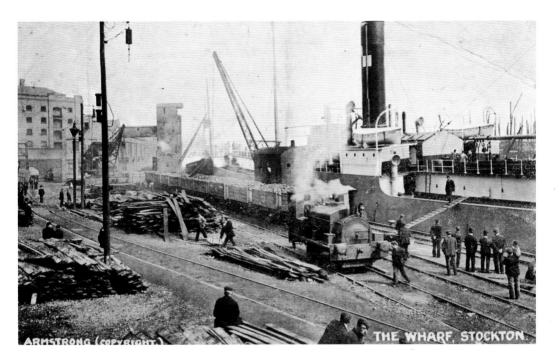

Wharfside Railways

Two rare Armstrong of Stockton postcards of a busy quayside in 1904. A small locomotive operates on the railway system serving the shipping. Rail wagons, cranes, warehouses and cargo boats complete the picture. Below, North Eastern Railway wagons carry metal goods, possibly railway lines for export. Stockton was a very busy port over the centuries, and particularly after the River Tees was made more easily navigable in the early nineteenth century.

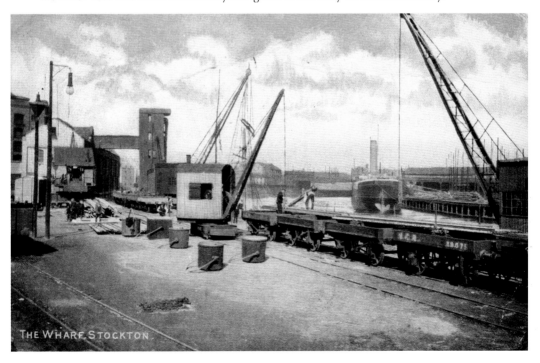

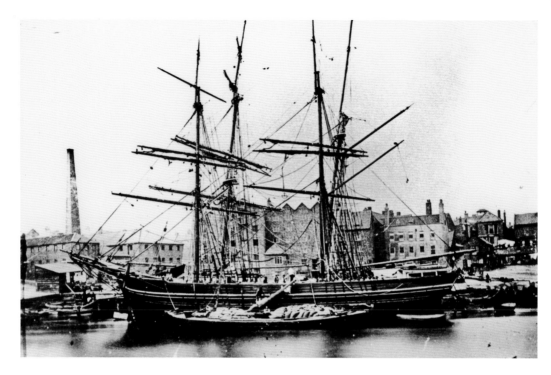

Early River View

A very early photograph from around 1870, showing a fine sailing ship moored at the Bishop's Landing Place on the Quayside. The Baltic Tavern can be seen beyond the stern of the ship, and heavy sacks are being moved between a river barge and the ship. At about the same point on the river, the modern replica of Captain James Cook's *Endeavour* now gives a touch of class to the town.

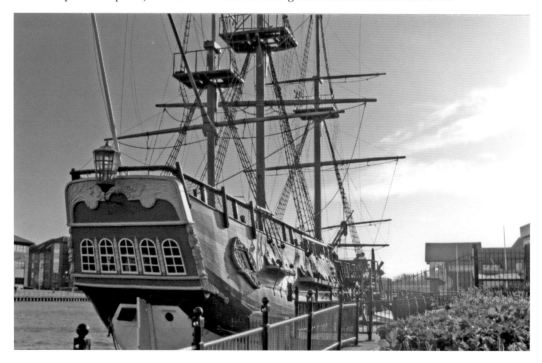

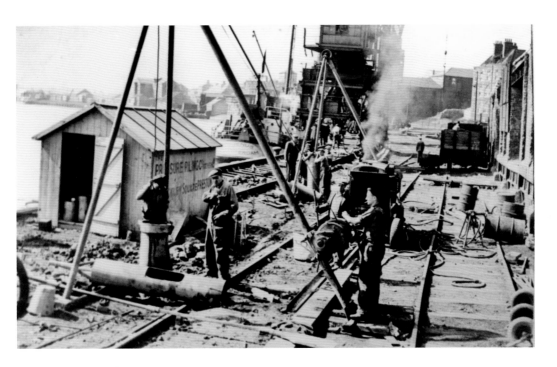

Quayside Maintenance

A later scene. From the signage on the workmen's hut, it is evident that pressure piling of the quayside foundations along the railway system was being undertaken in this view from, perhaps, the 1950s. Regular maintenance was essential in a busy port, but who could have foreseen the dramatic transformation that lay ahead? The modern Infinity Bridge provides a background to exciting water sports.

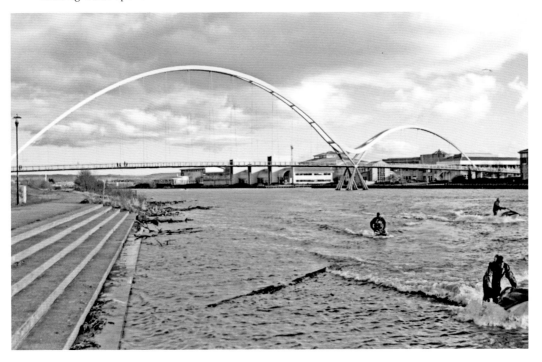

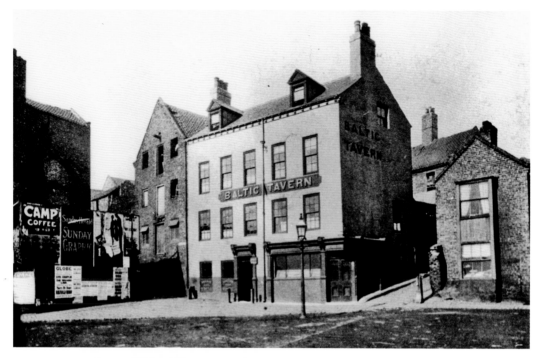

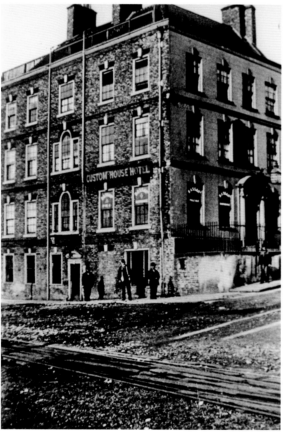

Two Quayside Public Houses
Important 'watering holes' for the visiting seamen, the many shipyard workers and others who lived in the narrow yards that lay between the parish church and the river, the Baltic Tavern and the Custom House Hotel were well-known features of Stockton life. The Baltic had originally been known as the Blue Anchor Tavern, and the change of name was thought to have reflected one of the main trading routes from Stockton. Housewife Lane leads up the right-hand side. The Custom House, built to regulate river trade in 1730, later became a hotel (seen here around 1890) and was apparently 'in ruins' by 1914. It was demolished in 1970.

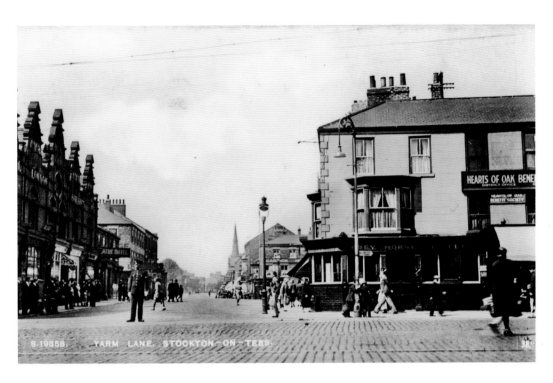

High Street Into Yarm Lane

A view taken in front of the Empire Theatre, looking down Yarm Lane. On the right-hand corner is the Grey Horse Hotel, and the decorative building on the left was the premises of the Royal London Insurance Company, who later replaced it with a modern office block. The traffic policeman is having an easy time!

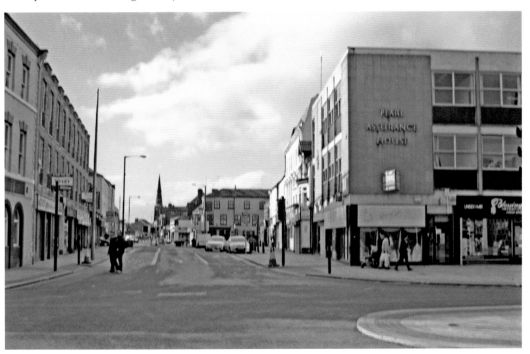

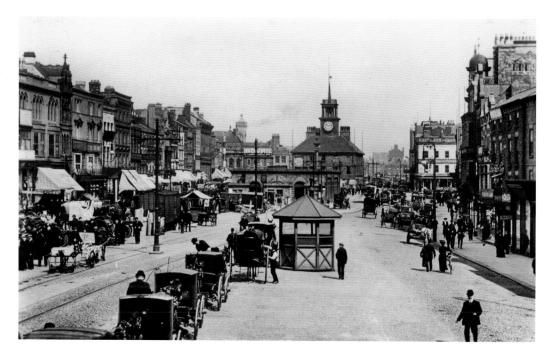

High Street Again

A clear view of the horse-drawn cab rank at the south end of Stockton High Street in 1909. The drivers' rest cabin stands in the centre, and it looks like a market day. Many more horses can be seen in the other market day scene, an early view with a steam tram, from the 1890s. The Borough Hall, built in 1857 and until very recently the site of the main post office, stands on the left with its elegant, wrought-iron canopy across the pavement.

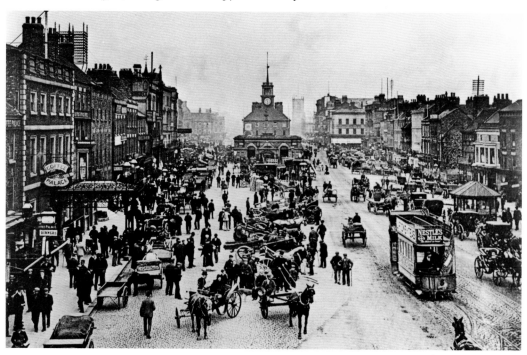

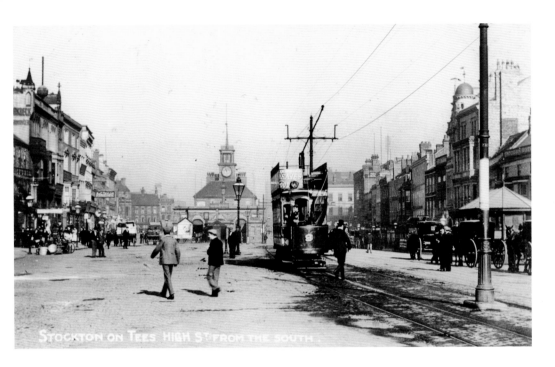

The Tram System

The electric trams replaced an earlier steam enterprise in 1898, with the trams running from Norton Green, through Stockton High Street and Thornaby on to Middlesbrough and North Ormesby. Early trams were open topped and open ended, with the driver enduring all kinds of weather. The horse-drawn taxi cabs can be seen on the right. Today's view has lost so much of the atmosphere created here.

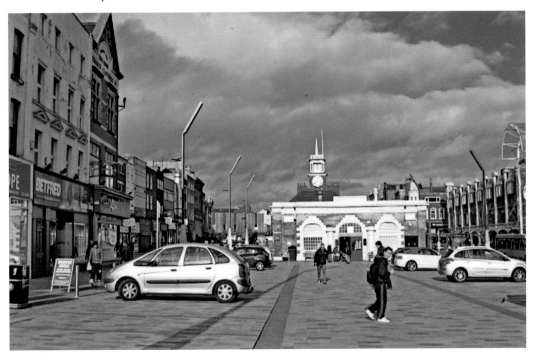

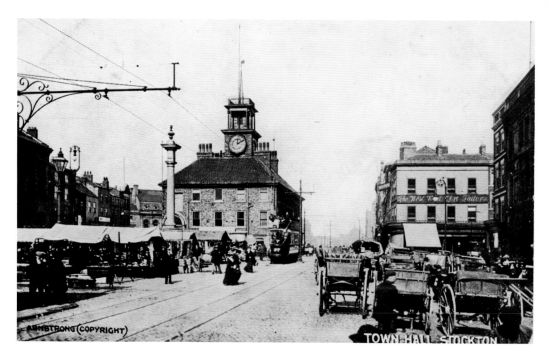

High Street, Market Day

An Armstrong postcard, taken between the Shambles and the Vane Arms Hotel, shows the town hall, built in 1735. Some of the market stalls and horse-drawn traps belong to farmers and other country dwellers visiting the market. By way of contrast, a scene from the early 1930s and also on a market day shows an interesting array of motor vehicles. Below, the historic Shambles market building has an advertising sign: 'Getting into hot water does not mean trouble if you use a gas water heater.'

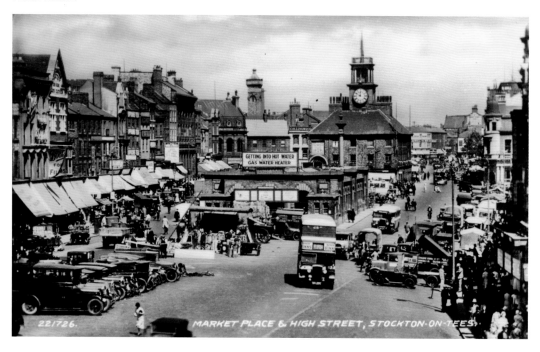

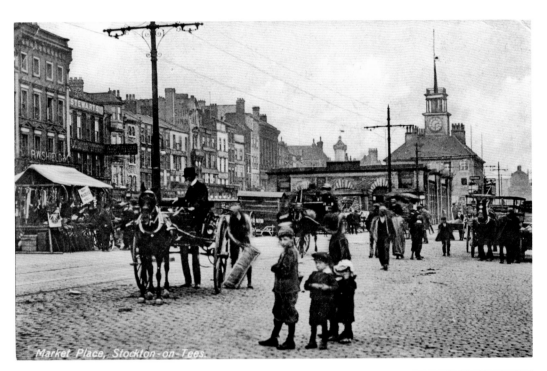

Market Place, Stockton-on-Tees.

Children at the Market

Standing on the cobbled Market Place, three small children notice the photographer taking a postcard view of the activities in the High Street. The tall poles carry the electricity supply for the trams. The low Shambles building in the centre was erected, originally as a covered meat market, in 1825. An attractive High Street feature, recently relocated, is the Dodshon drinking fountain, built by public subscription in 1878 in memory of John Dodshon, the president of the local Temperance Society.

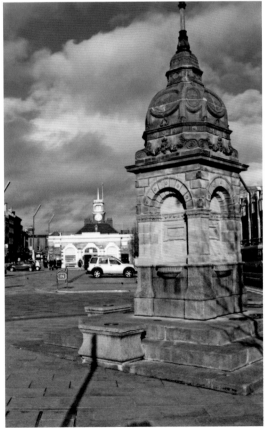

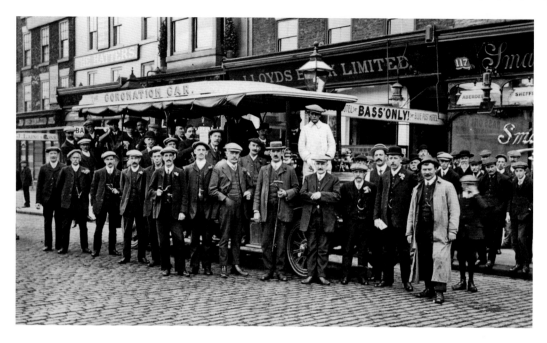

Excursion, Men Only!

A fascinating view of a charabanc, the 'Coronation Car', drawn up outside the yard leading to the Blue Post Hotel on the west side of Stockton High Street, close to the Shambles building. Some men are sitting on the bus, while many stand in front, nearly all of them with flat caps and gold watch chains. The driver wears a white coat. It is to be hoped that another charabanc had also been ordered for the numbers involved. Could it be the 1911 Coronation year? The Blue Post Hotel dated back originally to 1485, but lies hidden behind the High Street properties and has sadly now changed its ancient name.

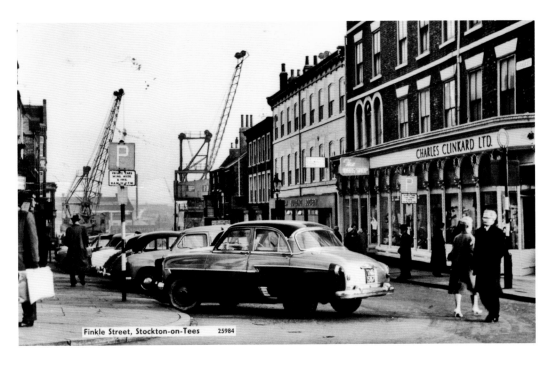

Finkle Street, Stockton-on-Tees 25984

From the Early 1960s

Two postcard views from the early 1960s show some interesting motor cars and the wharf cranes along the riverbank behind the east side of Stockton High Street. Finkle Street runs down to the Tees, and the right-hand side was demolished around 1970, when a very plain, large shopping centre was built. The printing establishment of Heavisides stood on the left-hand side of the street. The other postcard view is of nearby Silver Street, leading from the High Street to the riverside, and a large wharf crane can be seen in the distance.

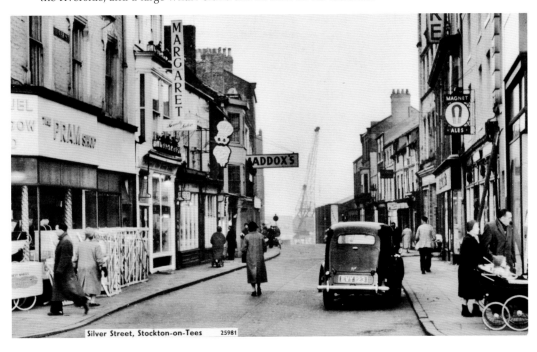

Silver Street, Stockton-on-Tees 25981

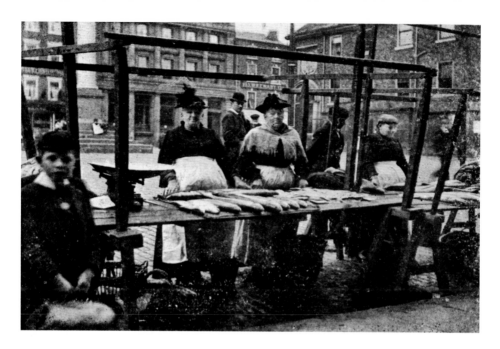

High Street, Heavisides Postcards

The firm of Henry and his son, Michael Heavisides, had operated a printing business in Stockton from 1856. Michael took over on the death of his father in 1870. He continued to produce a wonderful series of annual almanacs full of local history, and later a wide range of local postcards, and a number of fascinating local guidebooks. He himself took most of the photographs, including the ones shown here. The salmon on this stall by the town hall were caught in the Tees, and the geese would have walked to the market, perhaps from some distant farm. The caption reads, 'A familiar sight in Stockton High Street about harvest time.'

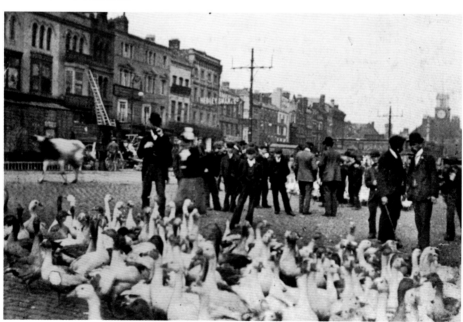

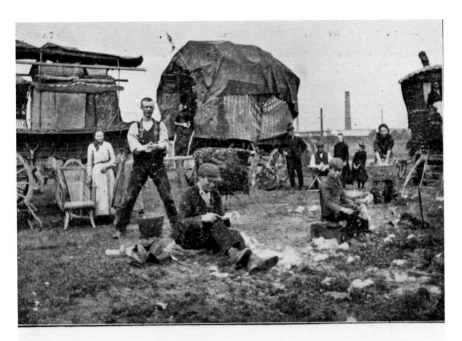

Gipsying near Light Pipe Hall Farm, Stockton-on-Tees.

More Heavisides Views

Light Pipe Hall Farm lay off Oxbridge Lane, near to the old Victoria Football Ground. Michael Heavisides' Almanac for 1908 records, 'Discussions have taken place in our Council Chamber as to the right of the gypsies to occupy this particular strip of land, but it appears that so long as no nuisance is committed, these nomadic people are outside the jurisdiction of the Town authorities.' Charlie Atkinson was a well-known local character working down by the quayside near to the end of Housewife Lane and close to the Baltic Tavern. He was both a carpenter and blacksmith.

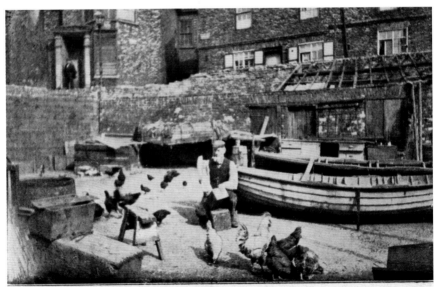

A quaint old Workshop on the Quayside, Stockton.

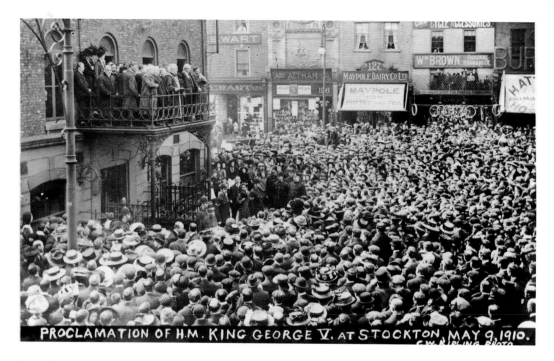

PROCLAMATION OF H.M. KING GEORGE V. AT STOCKTON MAY 9.1910.

Royal Proclamation, 1910

A massive crowd has gathered to hear the proclamation of His Majesty King George V on 9 May 1910. It is the custom to declare the new monarch immediately on the death of the preceding sovereign – Edward VII in this case. The Coronation usually takes place the following year. The town hall balcony seen here in the High Street was removed at a later date. The mayor on this occasion was Thomas Brownless Watson. Contrast this scene with the calm of a contemporary view.

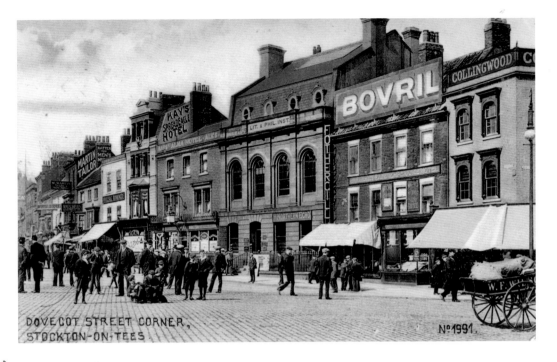

Dovecot Street

Leading in a westerly direction from the High Street near to the town hall, Dovecot Street has historically been an area of important buildings in the town. This Brittain & Wright local postcard was sent in 1909. The tall building in the centre is the offices of the Stockton Literary & Philosophical Institute, where members gave papers, lantern lectures, and musical and dramatic entertainments. Very little of this façade of buildings remains, and more modern buildings do not usually impress the public.

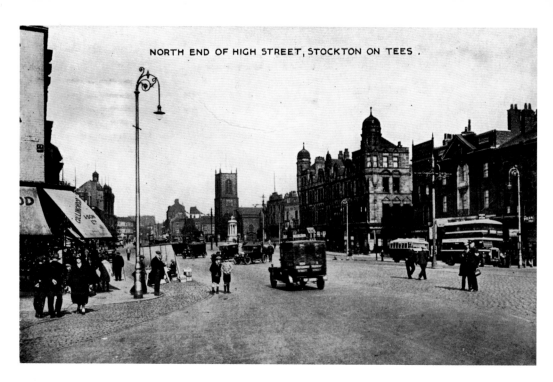

NORTH END OF HIGH STREET, STOCKTON ON TEES.

From Dovecot Street Junction

Looking across the High Street from the entrance to Dovecot Street, this view is dominated by the tall Victoria Buildings of 1897 in the centre, demolished in 1965. A peaceful postcard view from the 1930s depicts a police sergeant on the right keeping an eye on things. The latest redevelopment of the High Street dominates the present scene.

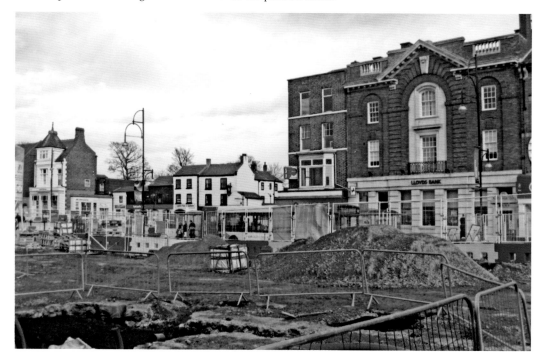

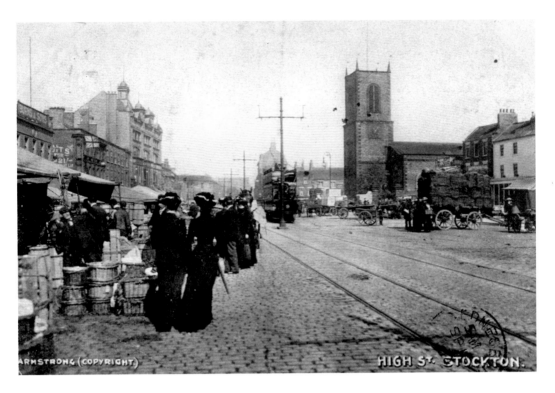

ARMSTRONG (COPYRIGHT.) HIGH ST. STOCKTON.

High Street, North End
An Armstrong postcard from 1904, again taken on a market day, with two ladies in elegant long dresses in the foreground. The trams dominate the lower picture, from a similar point in the High Street, and at this stage (1908) the motor cars and buses have yet to appear.

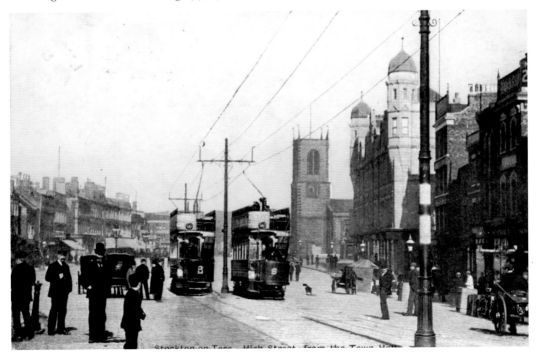

Stockton-on-Tees. High Street from the Town Hall.

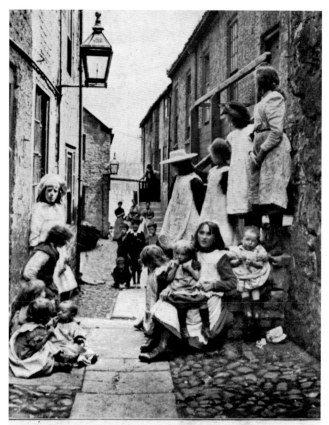

A Picturesque Group in Mason's Court.
(Off High Street, Stockton.)

More Heavisides Views
In his postcard of the children in Mason's Court, Michael Heavisides has produced one of the really stunning and quite charming memories of old Stockton, taken around 1905. Mason's Court ran from the High Street down towards the River Tees, from a point opposite the north end of the Shambles. It was not a very salubrious area; Heavisides refers to holding his breath when approaching the location shown in order to take his photograph. Some of the ladies in the lower view are seen exchanging views in Housewife Lane.

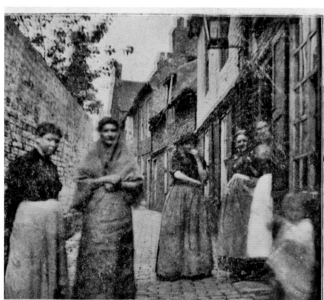

MORNING GROUP IN HOUSEWIFE LANE, STOCKTON

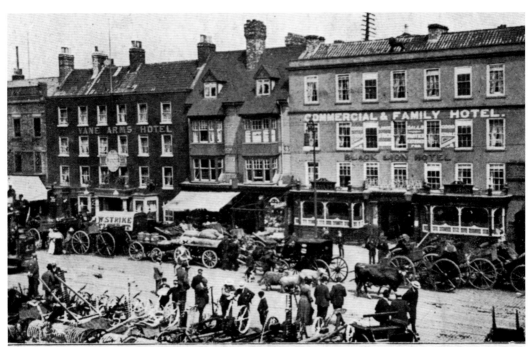

Market Day in High Street, Stockton.

Heavisides Again

Taken around 1907 and showing the famous east side of the High Street near the town hall, we can see two of the historic coaching inns that finally met their end in some appalling planning decisions made by the town council in the late 1960s. The Black Lion Hotel stands on the right, and the Vane Arms Hotel on the left. It is clearly market day, with cattle, sheep and much congestion. The shop of C. W. Laws stood next to the Royal Hotel, seen on the left, in the High Street, and again we see a flock of geese being brought to market.

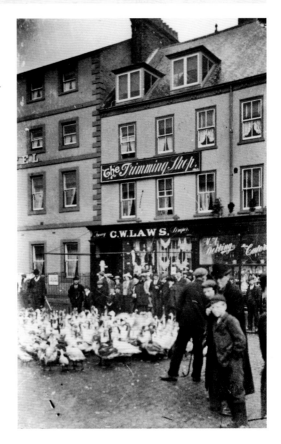

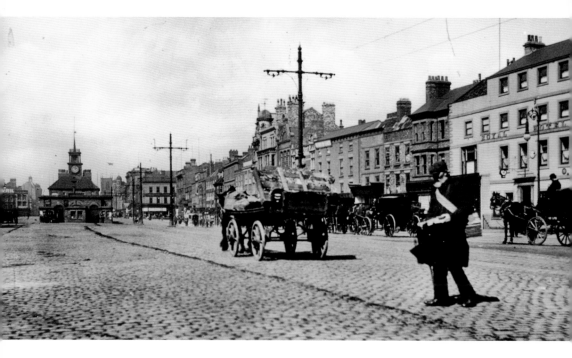

More High Street Scenes

An early view of Stockton High Street showing the historical cobbled road surface. The Royal Hotel stands on the right, behind an elegant horse-drawn carriage, with a tradesman's working horse and cart in the centre. From the early 1960s, by way of contrast, it is possible to see period vehicles: the soon-to-be-demolished Victoria Buildings in the centre, and Dovecot Street running off to the near left, past the shop of Collingwoods the jeweller's.

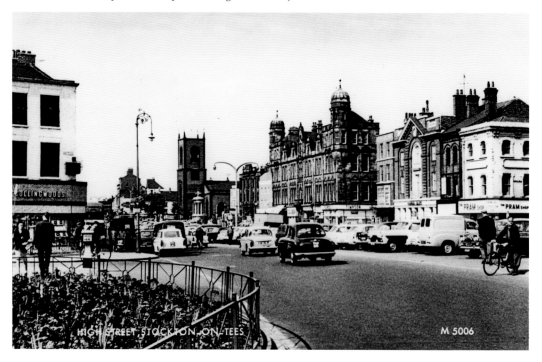

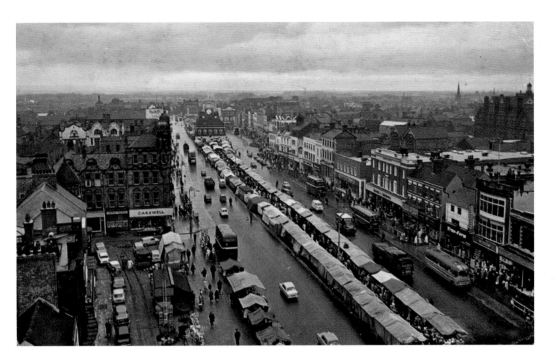

Stockton Market, High Street

The ancient Stockton Market is today but a shadow of its former self, as these two postcards, possibly from the 1950s, well illustrate. The upper one must have been taken from the top of the tower of the parish church, looking south towards the town hall. The lower one looks in the opposite direction, towards the parish church. Many of the local residents wish that these heady market days could return, but they also like to use the big supermarkets and the out-of-town shopping malls that have badly hit trading in the market and in the small local shops in Stockton.

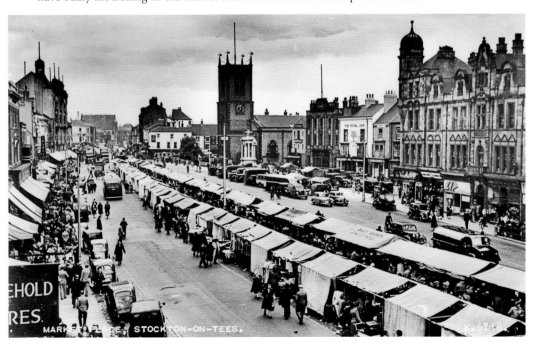

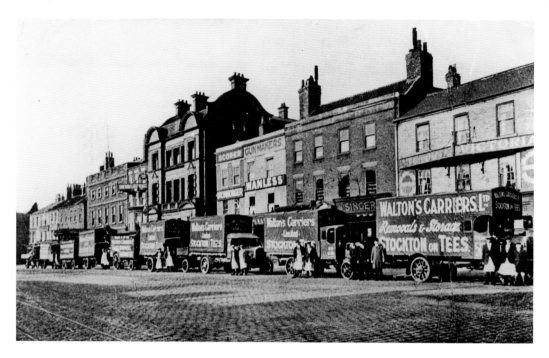

The High Street

An impressive convoy of Walton's removal vehicles, the staff posed in white aprons, lined up in the High Street in April 1924. They were apparently moving the contents of a large shop to alternative premises in West Hartlepool. The tallest building was the premises of the North Eastern Banking Company, later Martins Bank. The current view shows the fine market cross from 1768 in front of the attractive town hall building on a modern market day.

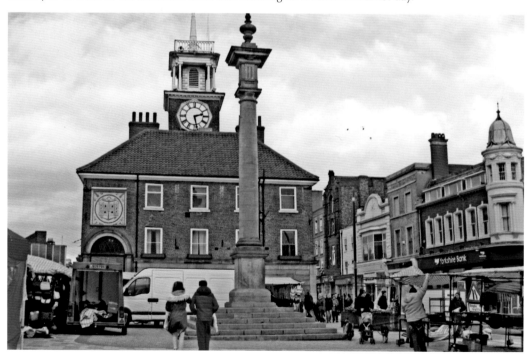

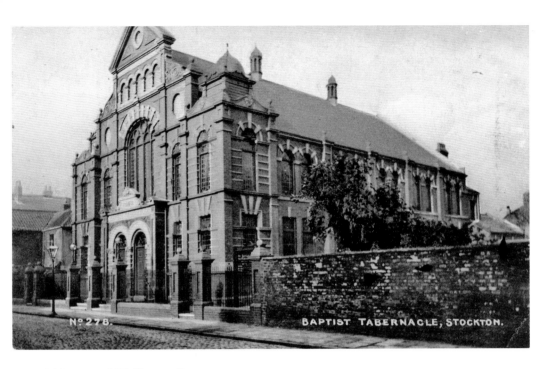

No 278. BAPTIST TABERNACLE, STOCKTON.

A Memory of Wellington Street

The Baptist tabernacle, opened in 1902 and seen here around 1905, stood in Wellington Street and combined external and internal architectural elegance with spaciousness. Always well patronised, it fell victim to development plans for central Stockton in more recent years, although an architecturally interesting new place of worship was built as a replacement on a high site near the river. It has also become a popular venue for classical concerts.

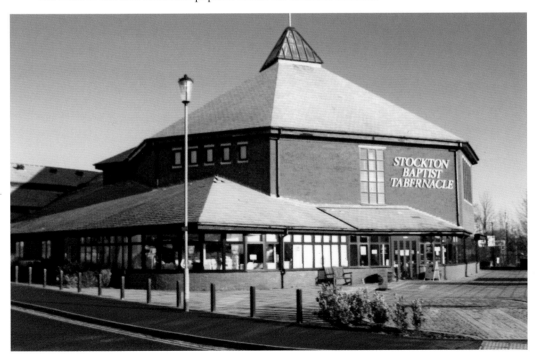

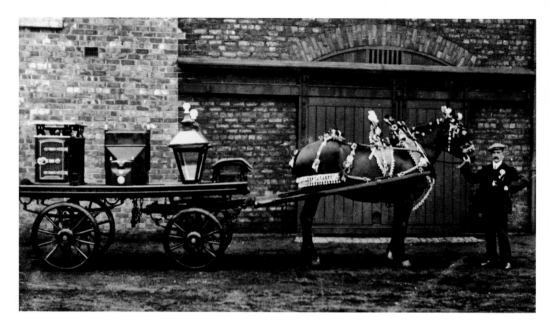

Stockton Corporation Gasworks

The decorated horse suggests that the local gas board were heading for a public event where they could advertise their products. Examples of appliances can be seen here: a gas cooker, a heater and some large gas lamps. The name of the enterprise can just be read on the original postcard, along the cart side. Another unusual form of advertisement is this police 'Wanted' postcard from January 1905. The card was issued the day after a major theft took place. Did they ever catch Frederick Price, I wonder? An interesting technique in the days when there were fewer newspapers, and no radio or television.

PHOTO OF F. PRICE. TAKEN ABOUT 18 MONTHS AGO.

Durham County Constabulary.
STOCKTON DIVISION.

WANTED AT STOCKTON-ON-TEES,

Charged with stealing a Cash Box containing about £35 in Gold, £25 in Silver, and about 25/ in Copper; a Silver Watch, No. 454.930, A Lady's Silver Watch, No. 22,739, from the Manager's Office in a Printing Establishment here between 6 and 6-30 p.m. on 4th January, 1905.

FREDERICK PRICE,

aged 18 or 19 years, about 5 feet, 5 inches in height. fresh complexion, sharp features, brown hair, thin build, speaks with Scotch accent, a Paper Cutter and a native of Edinburgh, where his mother, Mrs. Lunan is Housekeeper with Messrs. Kay & Sons, Union Hotel, Lothian Road. Dressed, when he left here in dark grey jacket and vest, dark trousers, grey cap.

MARKS : Nail second finger right hand discoloured and cut. He has recently had the Itch.

A man answering his description booked from Middlesbrough, for Edinburgh.

He is very much given to horse-racing, and associates with betting men.

The Cash Box, which contained besides the money, a large number of Postal Orders and Cheques was found forced open, lying on a vacant piece of ground near where Price lodged. None of the Cheques or orders are missing. An Account Book bearing Price's name was found among the Cheques, which he must have accidently dropped.

Please cause every possible enquiry to be made at all likely places in your district for the above named and described, who when found cause to be arrested ; or any information obtained please communicate with

GEO. HILDRETH,
Police Office, Stockton-on-Tees, Superintendent.
5th January, 1905.

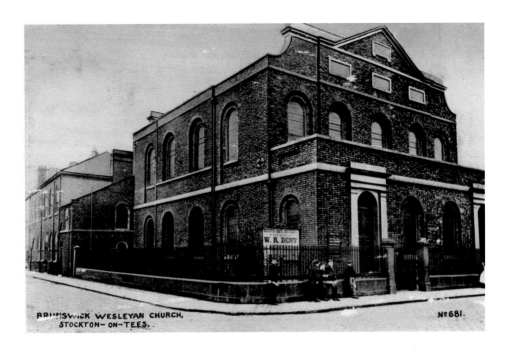

BRUNSWICK WESLEYAN CHURCH,
STOCKTON-ON-TEES.

Nº 681.

Brunswick Wesleyan Church

This fine church, built in 1823 in Dovecot Street, particularly flourished a century ago when the Sunday school had nearly 600 children and seventy teachers. It ceased to be a place of worship in 1971, and for many years afterwards served as a carpet showroom and warehouse. Its beautiful stained-glass windows were removed to the Preston Park Museum. Sadly, old age and the weather caused it to fall down without assistance a year or two ago, but thankfully nobody was injured. The site is now an undistinguished car park, but opposite stands Stockton's old post office building, opened in 1880, which operated until 1960 and is still attractive in appearance.

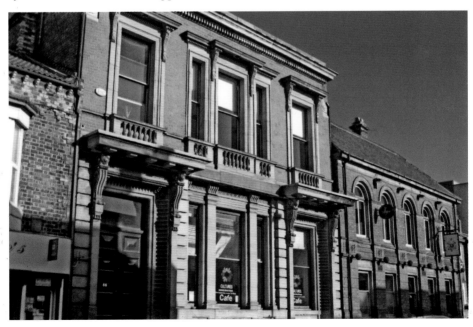

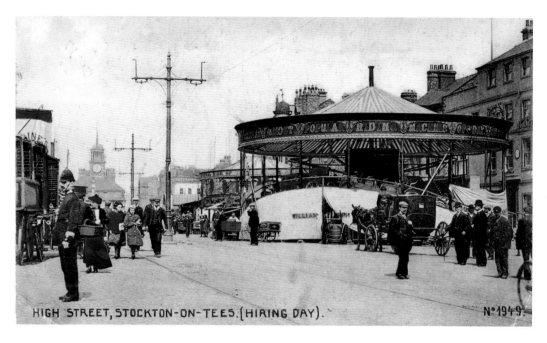

HIGH STREET, STOCKTON-ON-TEES. (HIRING DAY). N°1949·

Stockton Hirings and Fair

Traditionally, for generations, farm workers and house servants were hired for an annual salary each year at a public hiring event in the High Street. These amazing local Brittain & Wright postcards capture the atmosphere and colour of the occasion. Who can still remember a giant merry-go-round in the centre of the town? Yarm and Stokesley, perhaps, but Stockton? How sad that such excitement is now very much a thing of the past. The market cross, built in 1768, still dominates the central High Street area today, and the hiring and bargaining took place in its shadow.

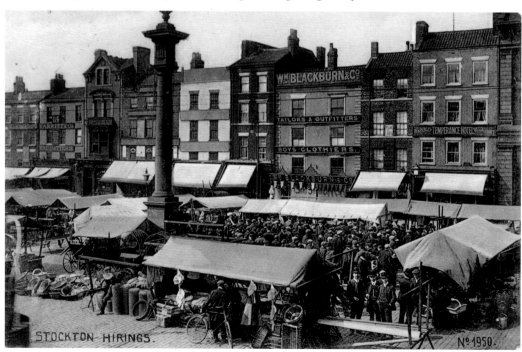

STOCKTON HIRINGS. N°1950.

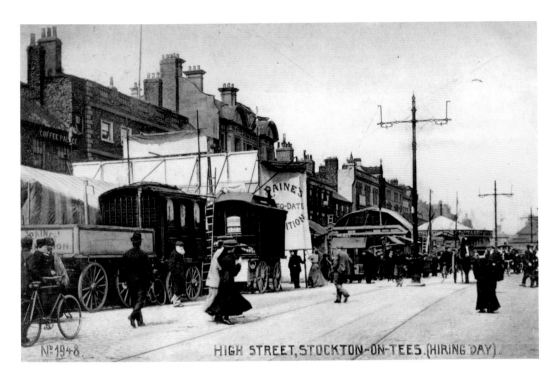

No.1948. HIGH STREET, STOCKTON-ON-TEES (HIRING DAY).

High Street

Another view of the High Street at the time of the annual hiring. Merry-go-rounds, sideshows and caravans dominate the scene. It all seems such a remote way of life to us now, but we can still recognise some of the buildings, including the North Eastern Banking Company building, now serving a quite different purpose.

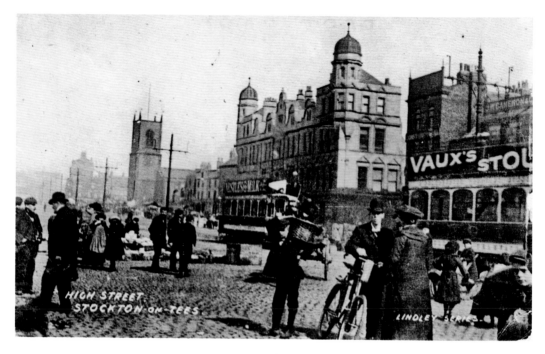

Victoria Buildings and Parish Church

Two views showing the elegant Victoria Buildings, dating from the late 1890s, with the parish church beyond. The open-topped trams were a familiar sight before the First World War, as was the horse traffic. The Victoria Buildings were demolished around 1965 and an appalling plain modern office and shop building was constructed in its place. That too has recently been demolished, with no sense of loss.

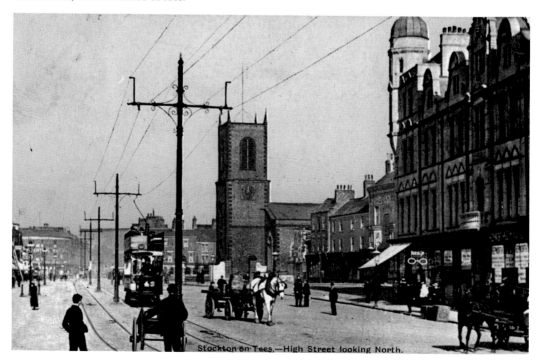

Stockton on Tees.—High Street looking North.

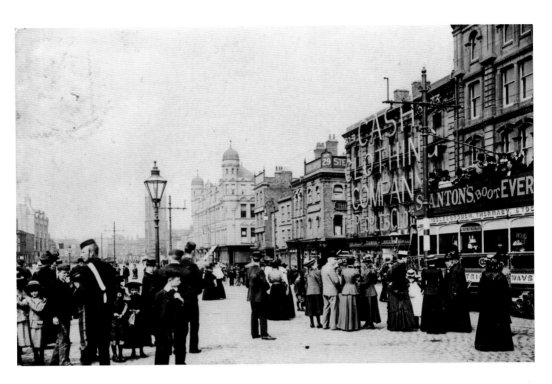

High Street Fashion Parade

An impressive 1906 postcard view of Stockton High Street, with elegant Edwardian ladies possibly waiting for the tram, their carriages, or simply enjoying a good conversation. Not a motor car is in sight, as there wouldn't have been many at this stage. The landscape continues to change, but not usually for the better.

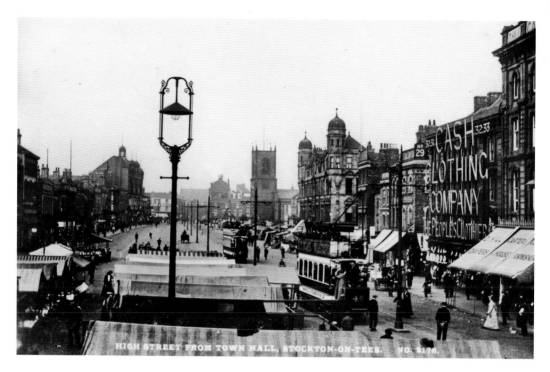

HIGH STREET FROM TOWN HALL, STOCKTON-ON-TEES. NO. 2176.

The Historic Market Place

Both views show some of the market stalls for the town market, which was originally granted in 1310. Over the years, its character has changed, and livestock have not figured here for a considerable period. Whereas the trams feature in the earlier picture, buses of various shapes and sizes and motor wagons came to dominate the landscape.

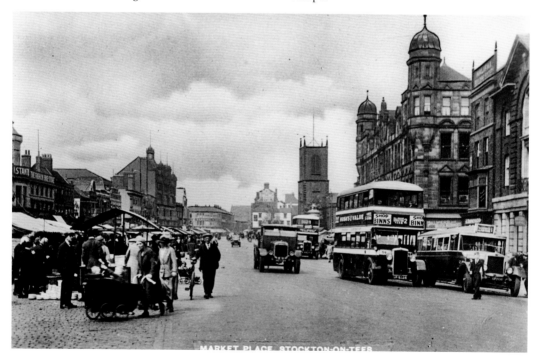

MARKET PLACE, STOCKTON-ON-TEES

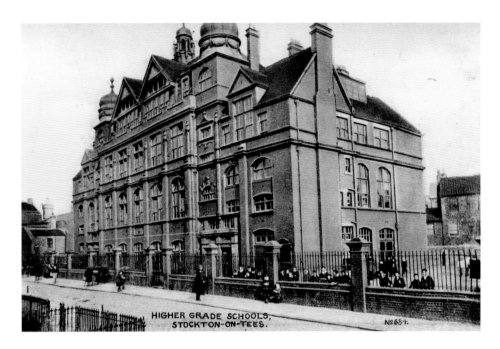

HIGHER GRADE SCHOOLS,
STOCKTON-ON-TEES.

Nº 684.

Higher Grade Schools

This impressive building dated from 1896, and its educational role changed over the years. It was in use until 1983 but was sadly demolished in the following year. The site was then simply used as a car park for many years until the building of the new shopping centre. The town children had to exercise in their school yard, as no playing fields were provided in those days. The Higher Grade School used the 'Swedish Drill', a sequence of exercises and movements that the teacher could learn in advance. He is seen calling out his instructions from the rear of the group.

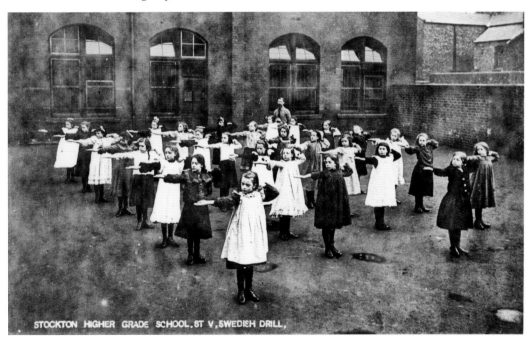

STOCKTON HIGHER GRADE SCHOOL. ST V. SWEDISH DRILL.

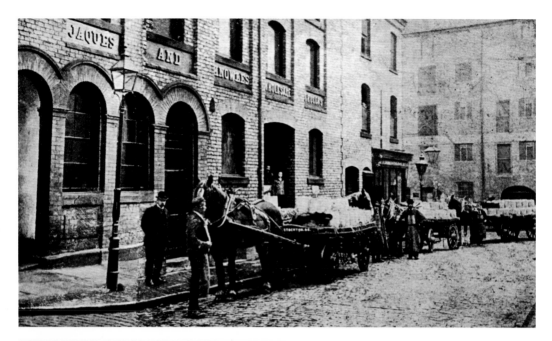

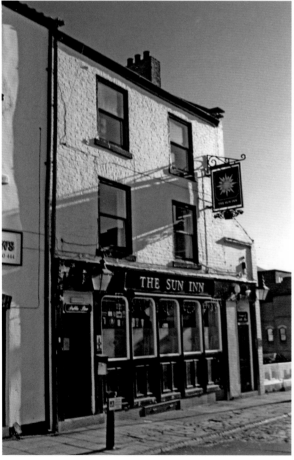

Jacques & Knowles

Located in Knowles Street, near to the Sun Inn, the establishment of Jacques & Knowles was a wholesale grocer's supplier. Their delivery carts operated from large warehouses, covering a wide area of the town and its surroundings. Nearby, the historic Sun Inn still stands defiantly amid all the recent waves of redevelopment.

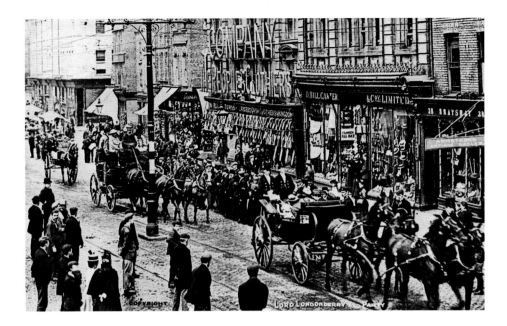

Going to the Races

A fine postcard view by Armstrong from 1903 of Lord Londonderry's party making their way from Wynyard Hall along the High Street to the races at Mandale, now close to the site of the Teesside Retail Park. An open carriage with footmen precedes a coach, each drawn by four horses. The party has just passed the end of Silver Street. Below, on a similar occasion at Brewery Bank, Thornaby, Lord Londonderry's party make their way back from the Races to Wynyard, through Stockton around 1904. Large crowds watch as they make their own way home past the Harewood Arms public house on the right.

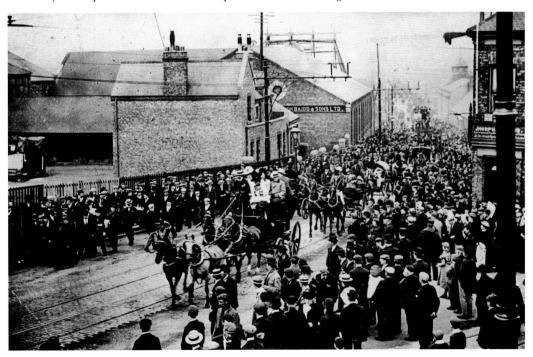

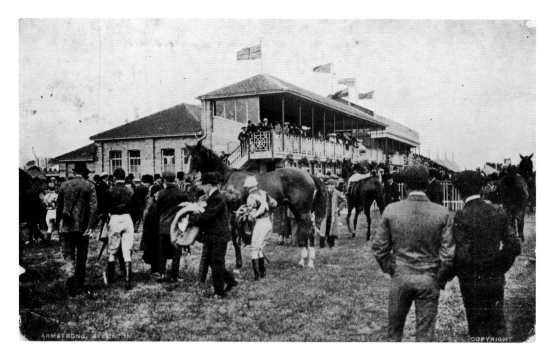

Horse Races of Two Kinds

Another Armstrong postcard from around 1910 entitled 'In the Paddock – Stockton Race Course' brings back memories of an important entertainment venue in the area. The races moved to their Mandale venue in 1855. By way of contrast, another Armstrong postcard shows the line-up for the donkey race, which was part of the ancient Stockton Cherry Fair, held in July and originating in the eighteenth century, if not earlier. This particular race was held at the old Victoria football ground in 1904.

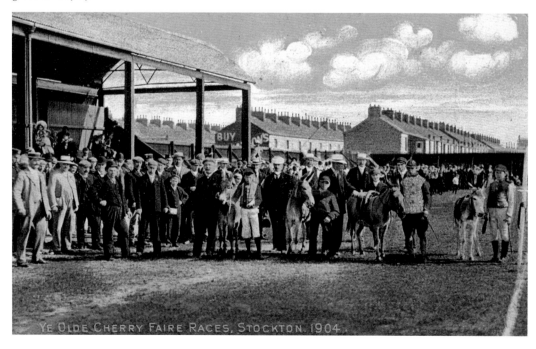

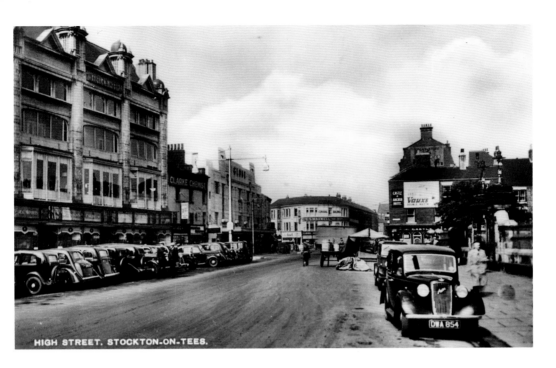

HIGH STREET. STOCKTON-ON-TEES.

M. Robinson's Coliseum Department Store

We see on the left the famous façade of the department store of Matthias Robinson & Sons, with branches also in Hartlepool and Leeds. This was a large, popular and innovative shopping venue, which no doubt influenced the buying habits of the local population from its opening in 1898. The picture is probably from the late 1930s. Note the orderly car parking in front of the store, something not allowed there nowadays. The Globe Theatre lies beyond, with Maxwells Corner in the centre distance and the parish church just out of sight on the immediate right. Today, this large shop belongs to Debenhams, and the Globe Theatre nearby is currently being restored to its former glory.

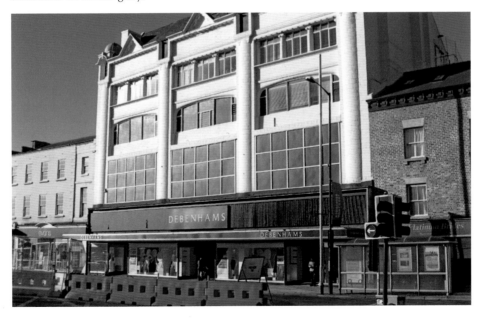

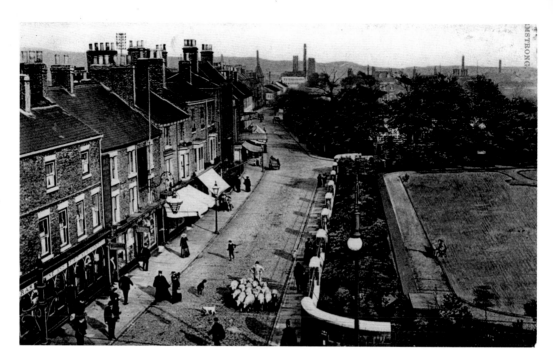

Sheep in Town

Sheep being driven along the then narrow Church Row towards the High Street in 1904. The grounds of the parish church can be seen on the right, the cattle market lies behind the trees, and the chimneys of the Stockton Malleable Ironworks can just be seen in the distance. Known later as Church Road, this area has a number of elegant town properties, the central one here dating from 1909.

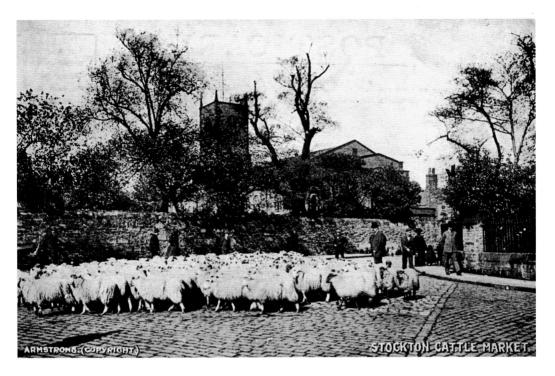

The Cattle Market

More sheep just down the road at the cattle market, approximately on the site of the present library, police station and the Baptist Tabernacle. The parish church stands in the background. Today, the library building is on the right, with the police station behind the camera.

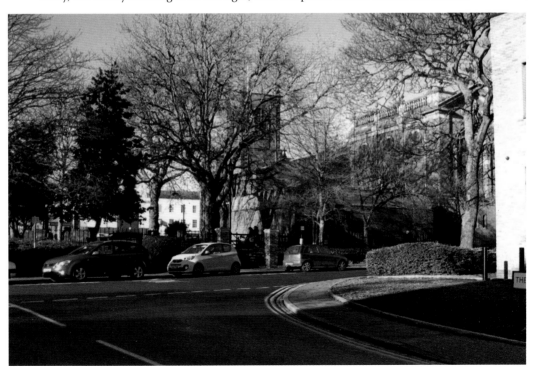

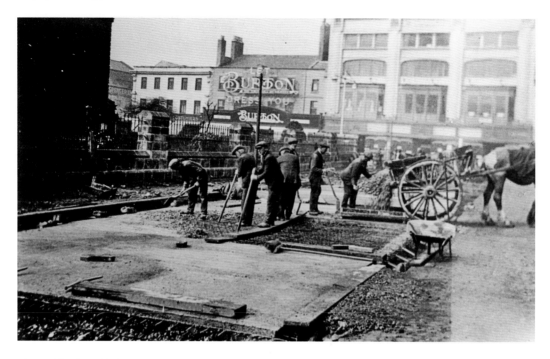

The Widening of Church Road, 1935

Increasing traffic led to the need to widen and improve Church Road. The parish church lies on the left, with the High Street running across the rear, in front of M. Robinson's Coliseum department store on the right, now Debenhams. The concrete is being laid from a horse and cart on to a wire mesh foundation. Further down Church Road, where an underpass and rail bridge were required, more fundamental preparatory work was in hand in May 1935.

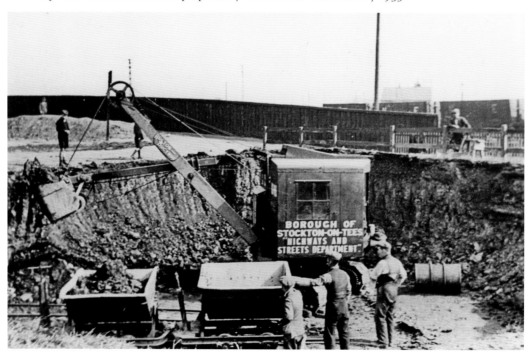

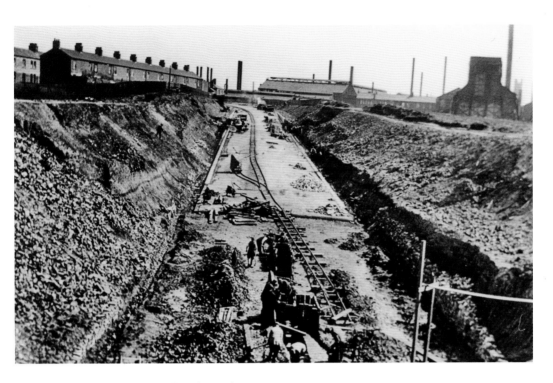

Construction Pictures, Church Road, 1935

The top picture shows the new road passing under the railway bridge on which the photographer is standing. The Malleable Ironworks is clearly visible in the background. A steam wagon owned by the Stockton-on-Tees Corporation Highways and Streets Department is seen here assisting in the Church Road project.

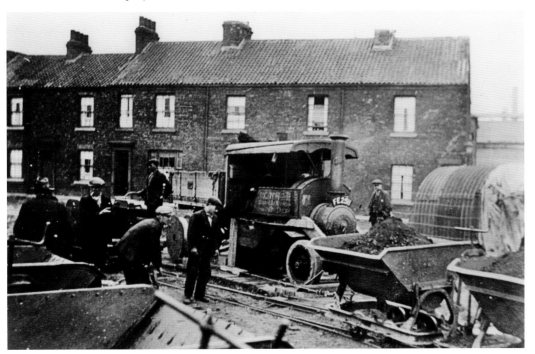

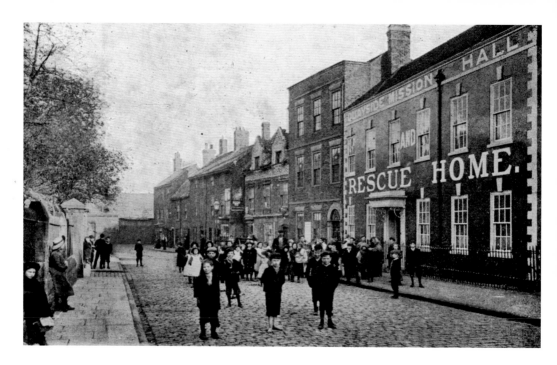

Quayside Mission Hall and Rescue Home

Situated in the Square, near to the cattle market, the Quayside Mission Hall and Rescue Home was founded in 1906 and offered accommodation at sixpence per night to thirty-two homeless men, and also provided hot meals to large numbers of children in the area when times were particularly hard. Formerly a manor house, it closed in 1973 and was then demolished. Sadly, not a lot has changed over the years, and although these buildings are long gone, the welfare needs of some members of our community are still a real concern.

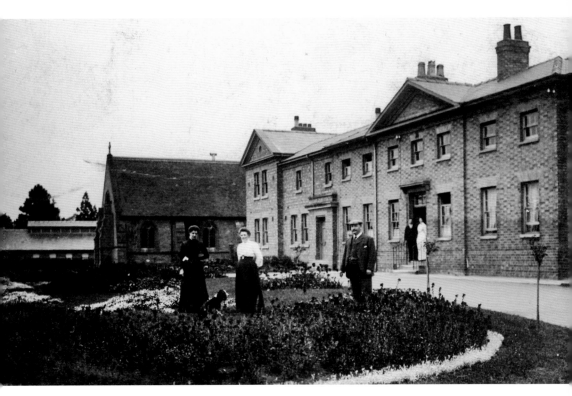

The Workhouse, Stockton

A rare postcard view of the workhouse in Stockton, which was located in Portrack Lane East and built in 1851. In 1900, the master of the workhouse was Mr W. Kimber, and the matron was Mrs G. Mitchinson. The postcard dates from a year or two later. There are still a few examples of early housing to be found in Stockton.

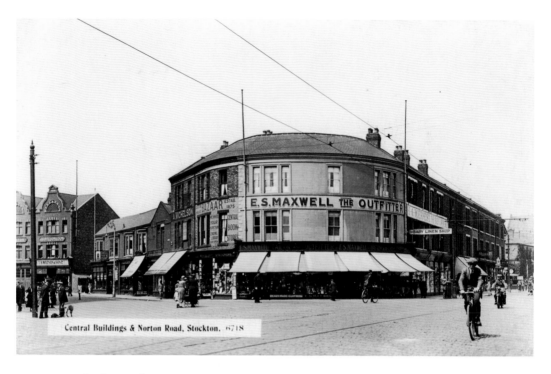

Central Buildings & Norton Road, Stockton. 6718

Maxwells the Outfitter

A very clear image of 'Maxwells Corner' in Central Buildings, at the junction of High Street, Bishopton Lane and Norton Road. The establishment, seen here with its external sunblinds in place, was a high-class outfitter's, which also offered school uniforms. The shop was something of a Stockton landmark. Maxwells acquired the business in 1913 from John Peckston, 'Complete Outfitter', and a stock sale took place at the changeover on 29 November that year, as illustrated here.

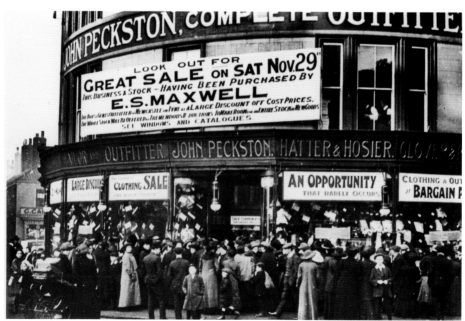

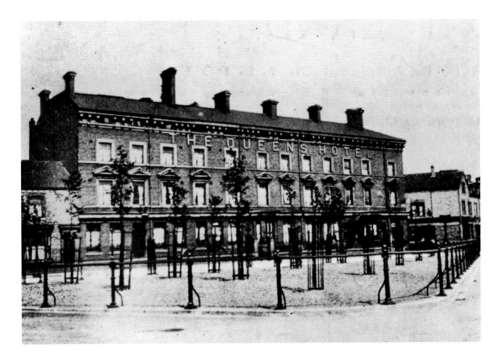

Station Approach

The Queen's Hotel, seen in this postcard view from 1905, stood near to Stockton station, and was well used by business people and visitors to the town. It was sadly totally destroyed by a mysterious fire in 1981 and never rebuilt. The station was originally a substantial set of buildings and an important part of the local and wider transport system. Over the years its structure was diminished, but this view of the North Eastern Railway landmark confirms its early dimensions.

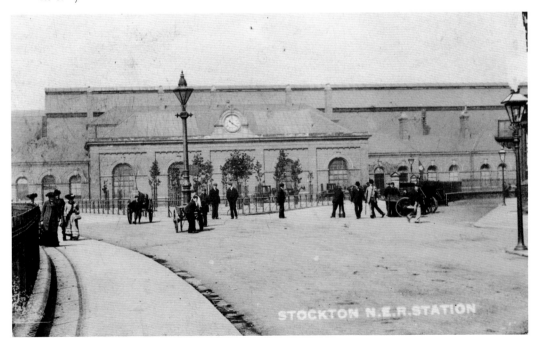

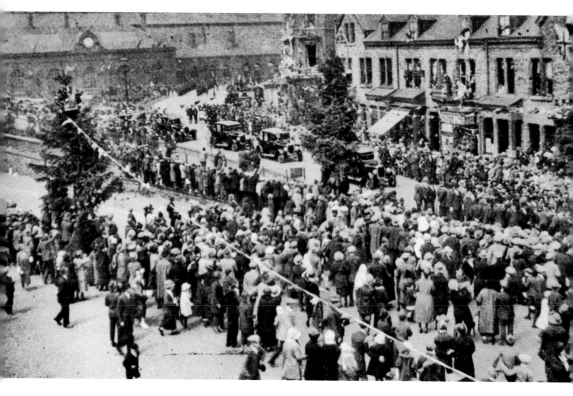

Railway Celebrations, 1925

The Stockton & Darlington Railway is deservedly famous for being the first passenger-carrying steam railway in the world. Its initial excursion took place on 27 September 1825, amid much ceremony. The centenary of that occasion was marked in 1925, when a reconstruction of the train made a similar journey, attended by the Duke and Duchess of York, later King George VI and Queen Elizabeth. These postcards capture the scene at Stockton station.

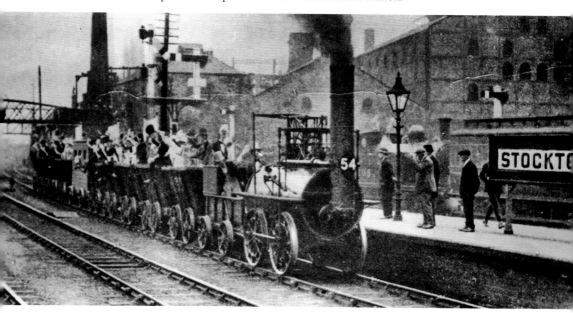

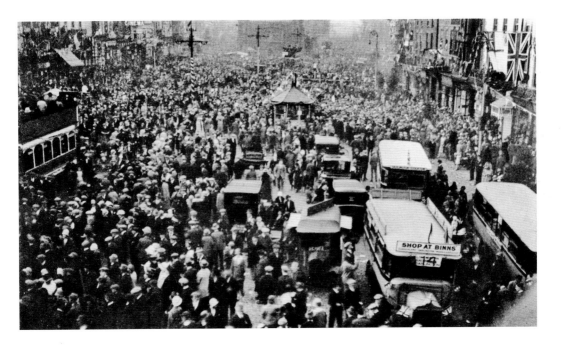

Railway Decline

Today the railway presence in Stockton seems much less important, and its history has in many ways been neglected by the town. The crowds in the High Street show the enthusiasm for the centenary celebration on 2 July 1925. By way of contrast, in February 2014, a special exhibition of North Eastern Railway's A4 Pacific steam locomotives from the 1930s was held at Shildon, where the original journey to Stockton began in 1825. Huge crowds attended to see the six famous engines on view, including *Mallard*, which holds the world speed record of 126 mph for a steam locomotive, achieved in 1938. Of course, there are now many other effective methods of personal travel available to us all.

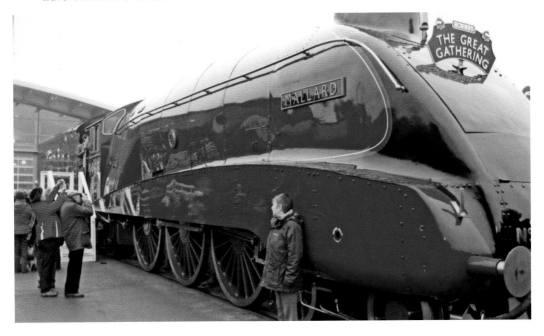

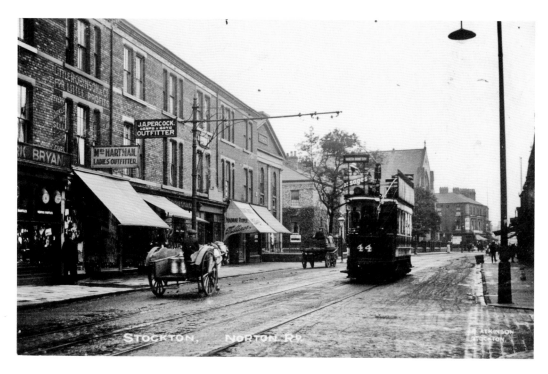

Norton Road, Stockton

Leading northwards from Stockton High Street, Norton Road contained many shops and small businesses around 1910, and was served by the tram route up to Norton Green. Much of the property seen here has since gone, including the two churches on the left-hand side of the picture with the tram. These views were taken just beyond Maxwells Corner.

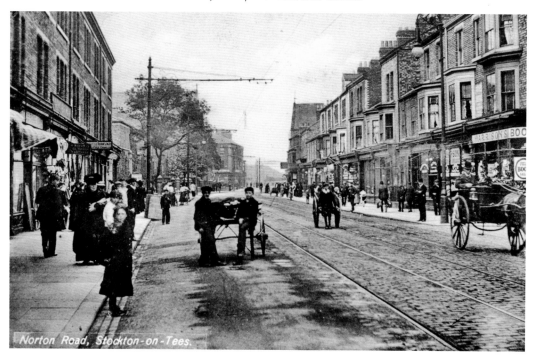

Features on Norton Road

St Mary's Convent School was associated with the Roman Catholic church of St Mary's, and was established in the early 1900s in a building that was formerly the 'Diocesan Training Home for Servants'. Some promotional postcards were produced by the new school, and this one shows the girls relaxing, including one sitting on an ornamental flower tub. One of the few early and attractive buildings remaining in Norton Road is the North End Steam Building Works owned by Eugene E. Clephan, all inscribed on the front of the building. He is described as a surveyor and builder who also operated a sawmill. The famous and valuable 'Dice Players' painting at Preston Park Museum was left to the town by his cousin in 1936.

St. Mary's Convent School, Stockton an Tees.

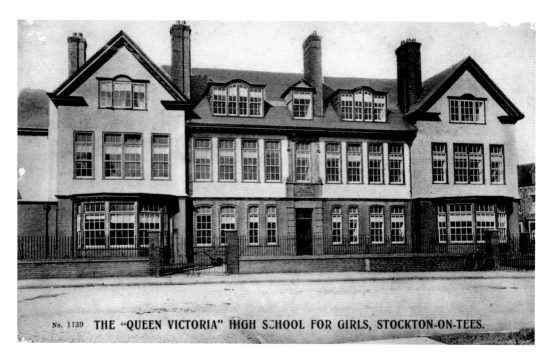

No. 1139 THE "QUEEN VICTORIA" HIGH SCHOOL FOR GIRLS, STOCKTON-ON-TEES.

The Queen Victoria High School for Girls

The school in Yarm Road was opened on 28 October 1905 by Princess Henry of Battenburg, appropriately the youngest daughter of Queen Victoria. It gained a fine reputation as a girls' independent school before later joining with the Cleveland school to form the new Teesside High School at Eaglescliffe in 1970. Public interest in the royal visitor is well illustrated here. The school building was demolished in the early 1970s, and a modern public house carrying the Queen Victoria title was built on the site.

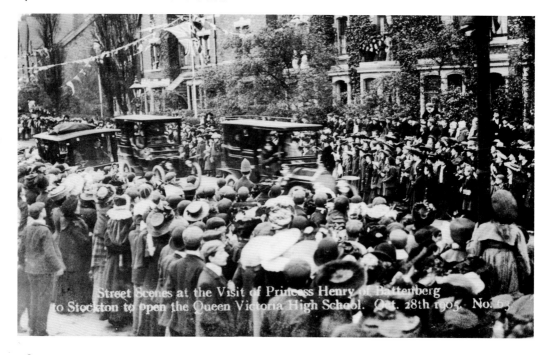

Street Scenes at the Visit of Princess Henry of Battenberg to Stockton to open the Queen Victoria High School. Oct. 28th 1905. No. 5

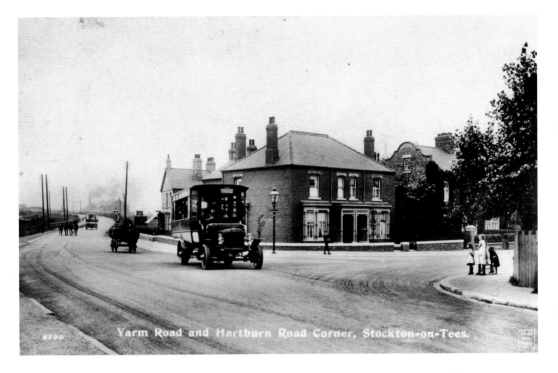

Yarm Road and Hartburn Road Corner, Stockton-on-Tees.

Early Transport

An impressive early bus travelling from Yarm to Stockton, at the junction of Yarm Road with Hartburn Lane, followed by a more traditional horse-drawn farm cart. Four horses in the distance are approaching abreast, and another similar bus can just be seen disappearing towards Yarm. Not much traffic then, but the children are observing the Highway Code before they step into the road.

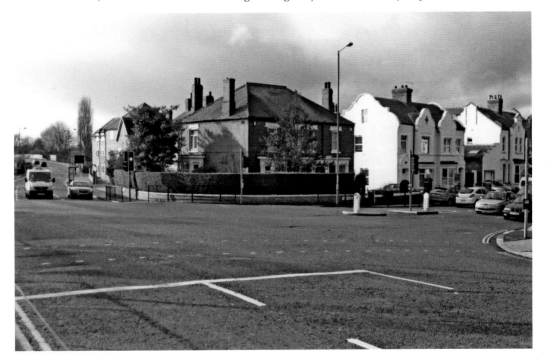

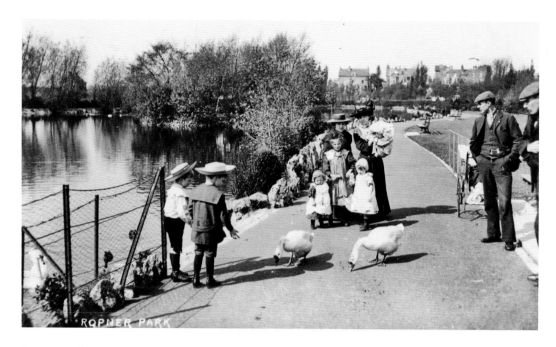

Ropner Park

Every town aspires to provide an attractive park for the benefit of its urban dwellers, and Ropner Park on Hartburn Lane certainly met this need. When it was opened by the Duke and Duchess of York on 4 October 1893, it was on the edge of the countryside. Forty acres of big open grassy spaces, a spectacular fountain, a large lake, an open-air theatre – these were all very appealing to those living in the nearby town housing. The park was a gift from the shipbuilder Sir Robert Ropner of nearby Preston Hall. Falling into decline in more recent years, it has recently had a major and impressive refurbishment.

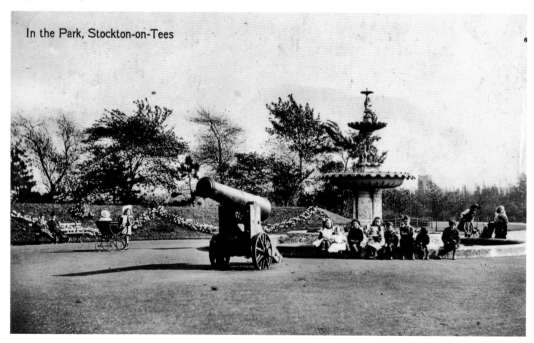

In the Park, Stockton-on-Tees

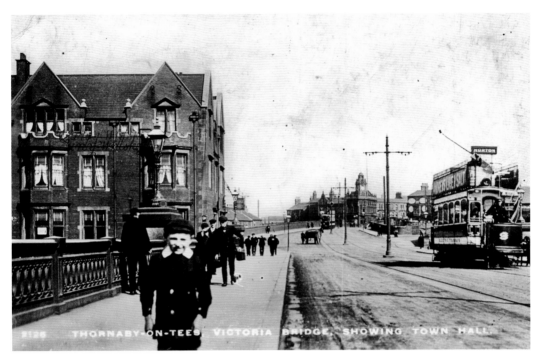

THORNABY-ON-TEES VICTORIA BRIDGE, SHOWING TOWN HALL.

Approaching Thornaby

A postcard view taken on the Victoria Bridge, which opened in 1887 to commemorate the Queen's Golden Jubilee. Thornaby Town Hall stands in the centre distance. Up to 1894, when Thornaby became a borough in its own right in the North Riding of Yorkshire, it was known as 'South Stockton'. The Bridge Inn on the left was demolished many years ago, but a very large, modern student accommodation building now dominates the bridge landscape on the Stockton side. The tram is heading for Norton High Street and the Green. A modern close-up shows the attractive Thornaby Town Hall building, somewhat neglected in recent years and the subject of some dispute between the Stockton and Thornaby local authorities.

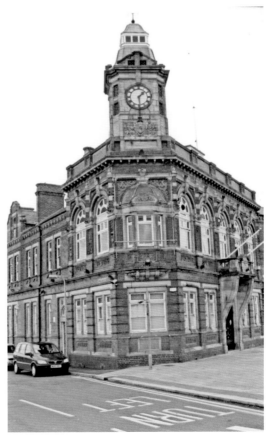

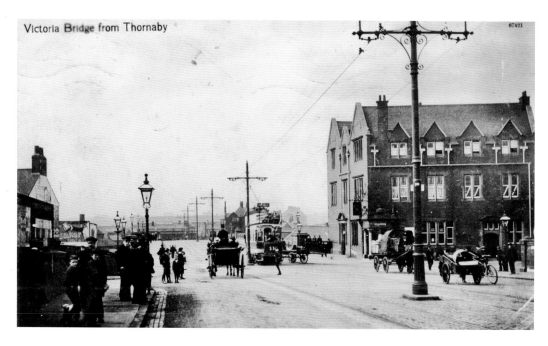

Victoria Bridge from Thornaby

Across the Tees

Looking back towards Stockton, with the Bridge Inn now on the right, an open carriage approaches the Victoria Bridge while the open-topped tram heads towards Thornaby and Middlesbrough. A few more yards into Thornaby and we see a detachment of cycle-mounted soldiers pushing their bicycles over the road bridge at Thornaby railway station, having just crossed the Victoria Bridge. The Cleveland Hotel is in the background. Is the First World War imminent?

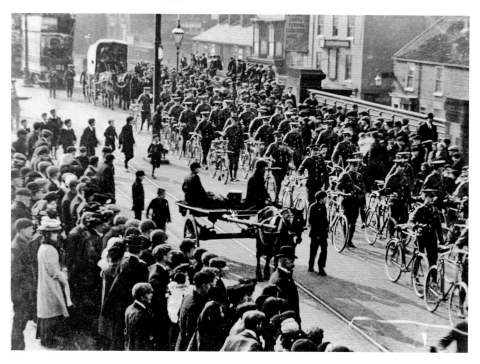

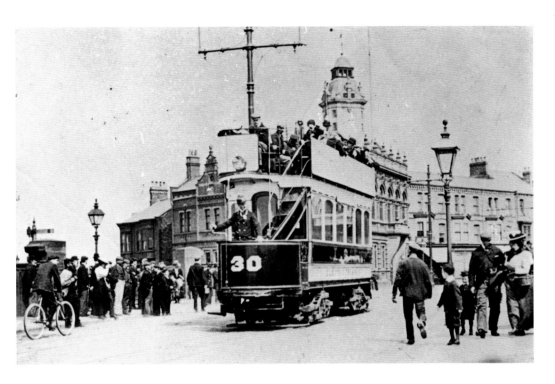

Old and New Scenes

University students are an important part of the Teesside economy, and they need somewhere to live. This modern accommodation building (seen below) was, however, criticised for being such an obtrusive and chunky feature to be built on the riverside next to the Victoria Bridge. Above, the early photograph shows a tram approaching the bridge from the Thornaby side, with the Thornaby town hall, built in 1890, behind the tram. Thornaby railway station lies just off to the left.

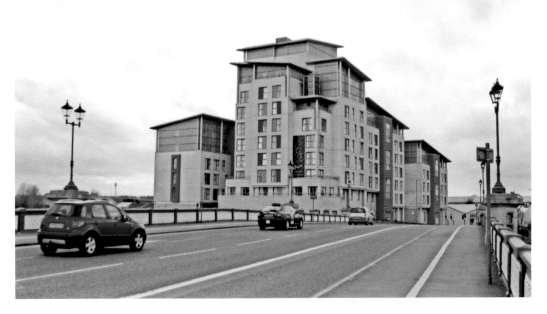

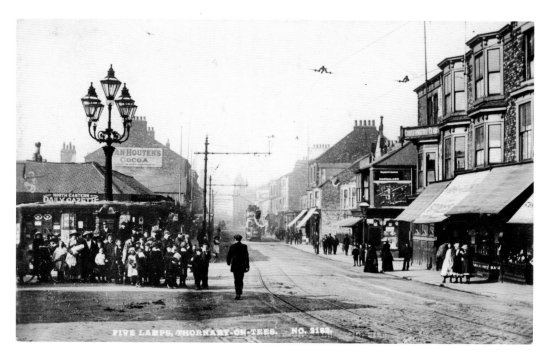

The Five Lamps Junction

The famous 'Five Lamps' area of old Thornaby was viewed by some of the locals as a town square where people met. The original lamp standard was very ornate and had to be renewed in later years because of corrosion caused by local industry. The area was full of interesting small shops right up to the 1960s. The upper picture looks down Mandale Road towards the town hall, while the lower view faces towards Middlesbrough.

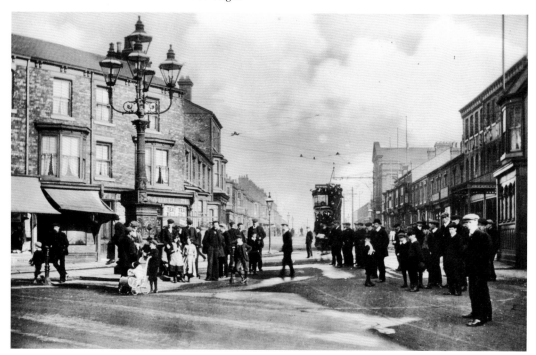

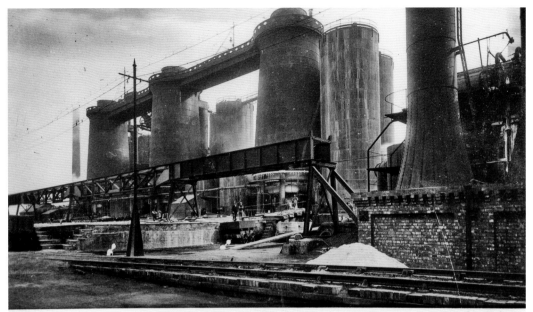

WHITWELL & COY.'S BLAST FURNACES, THORNABY VALENTINES SERIES

Industry in Thornaby

Despite being on the edge of agricultural land, Thornaby's housing expansion in the second half of the nineteenth century arose from the rapidly growing industry by the River Tees. Industrial postcards are keenly collected, often representing massive long-gone enterprises that gave the British Empire its strong global influence. Whitwells began production in 1862 and eventually closed in 1925. Head Wrightson became a significant international business, which continued until modern times.

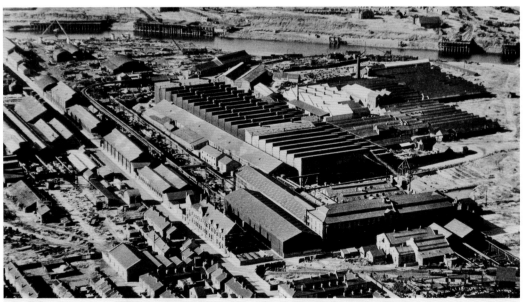

8622. AERIAL VIEW OF:- HEAD, WRIGHTSON & CO., LTD.,
MAIN WORKS, TEESDALE IRON WORKS, THORNABY-ON-TEES.

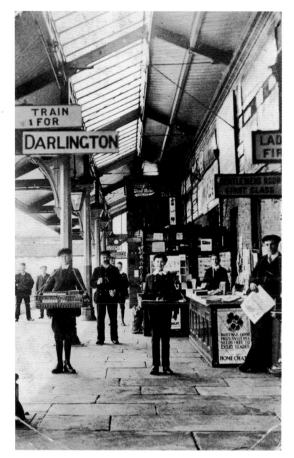

Eaglescliffe and Egglescliffe

There are debates about the spelling of this area of the Stockton borough, but the ancient village area around the Green and its historic church are usually regarded as Egglescliffe, while the broader surrounding area developed in later times is usually known as Eaglescliffe. This fascinating view of Eaglescliffe station dates from about 1908, with several staff offering a warm welcome to the traveller. The aerial view of the chemical works at Urlay Nook was taken in the 1930s. Sadly, both sites are now either much reduced or abandoned.

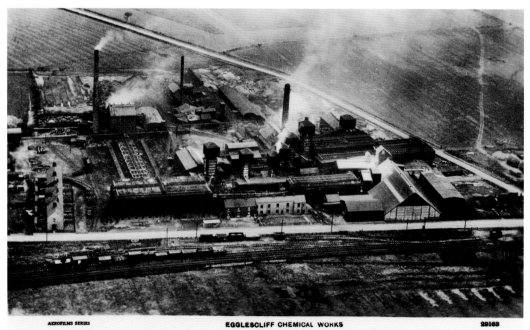

AEROFILMS SERIES EGGLESCLIFF CHEMICAL WORKS 29163

66

The Clarence Potteries Company, Limited,

STOCKTON-ON-TEES.

PLEASE BEAR US IN MIND WHEN ORDERING

FOOT WARMERS.

PRESSED SHAPE. 1½, 2, 3, 4 PINT.

THROWN SHAPE. 1½, 2, 3, 4, 6, 8 PINT.

WITH SCREW STOPPERS AND RUBBER WASHERS

Stockton Advertising Postcards

A curiosity of the postcard-collecting world is the range of advertising publications produced at the height of the postcard craze before the First World War. Here are a couple of unusual examples in different fields of interest. The Clarence Pottery, shown here, was situated in the Grove Terrace area on the east side of Norton Road near to the Mount Pleasant Mill. Mr J. K. Wells' premises in 1906 were in Castle Gate, down the side of the Castle Theatre off Stockton High Street, and his home residence was at No. 4 Balaclava Street, near to the railway station.

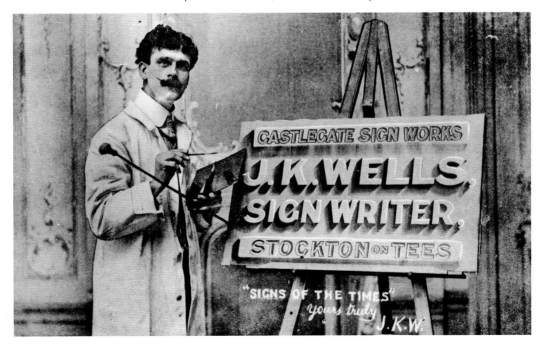

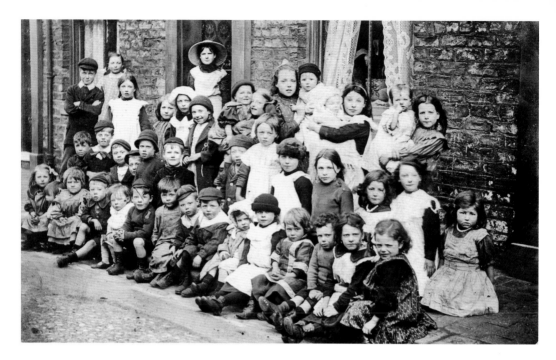

Local Children on Camera

Early photographs of children are a powerful reminder of contemporary lifestyles, fashions, health, and economic wellbeing. A wonderful Stockton street scene from 1908 shows all the children with shoes or boots and even a few smiles, and all are paying attention to the photographer. Young girls were already experienced in looking after the young babies. The school photograph is of the Robert Atkinson Mixed School in Thornaby in 1912, with Miss Dewhirst on the left and Miss Tate on the right.

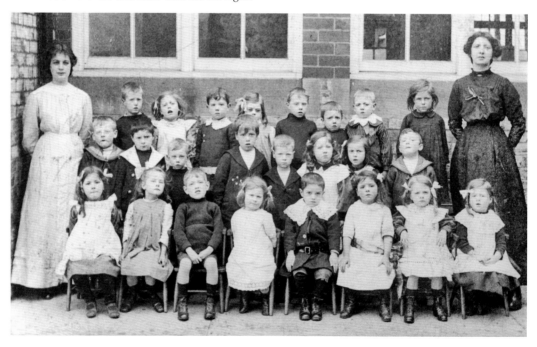

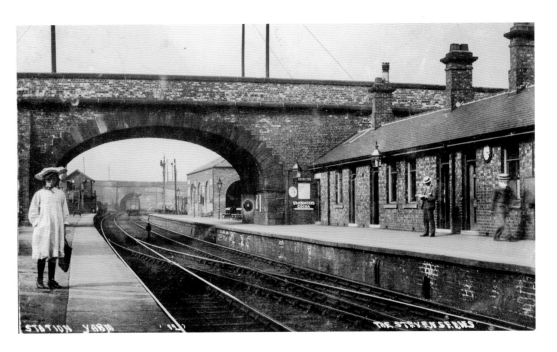

The Railway, Yarm

A fine view of Yarm station in 1912, looking northwards towards Eaglescliffe. A young girl in a pinafore dress awaits her train, as does the gentleman with the straw boater hat on the opposite platform. The station closed to passengers in 1960. Constructing the railway line at Yarm required a huge viaduct to cross the river and the low area of the town. Completed in 1851, it comprises forty-three arches, mostly in brick, with stone for the two main arches over the river. The modern view shows these central arches standing over a very full River Tees. Above the middle pillar is a large stone inscription about the building of the bridge and viaduct.

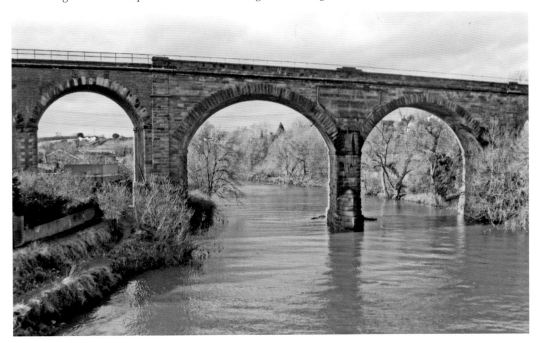

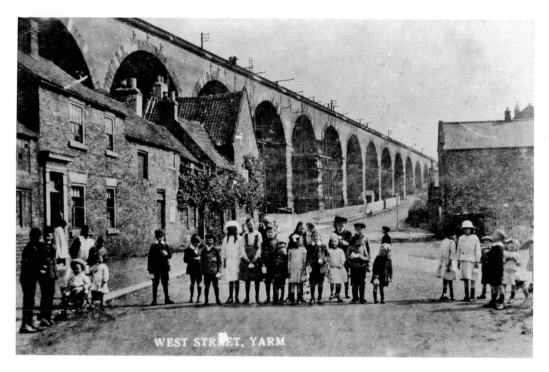

WEST STREET, YARM

Contrasts

In the shadow of the spectacular viaduct, a children's group poses for the postcard photographer in West Street, Yarm, in 1916. Contrast that with a modern view of West Street, where the motor car dominates. The railway overhead still operates for both passengers and freight, but the Yarm passenger station is now on the southern outskirts of the town, on Green Lane.

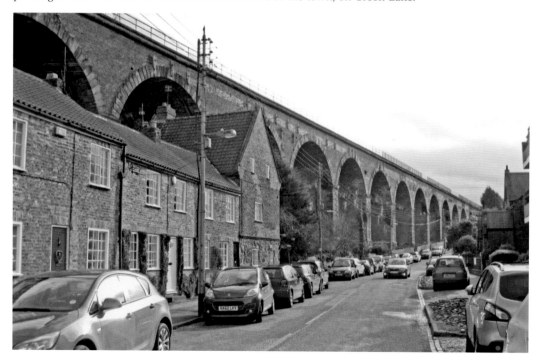

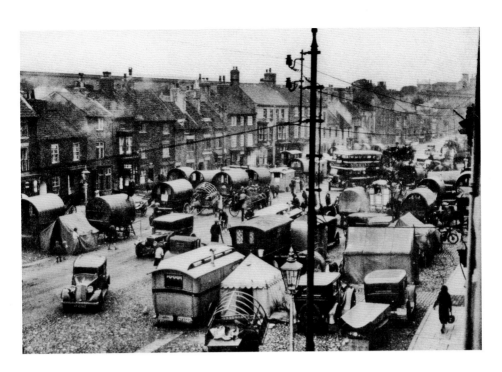

Historic Yarm Fair

A fascinating view of the annual street fair at Yarm around October 1930, looking north from near the town hall. A number of the traditional gypsy 'vardo' caravans can be seen, along with more modern versions, some large motor cars and a double-decker bus. Horses were traded at the fair, and exciting roundabouts and other entertainments were provided, as illustrated in the postcard from 1909.

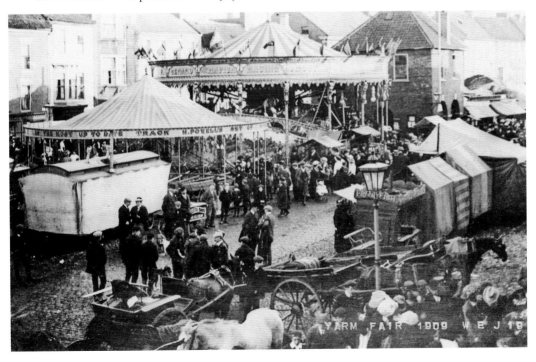

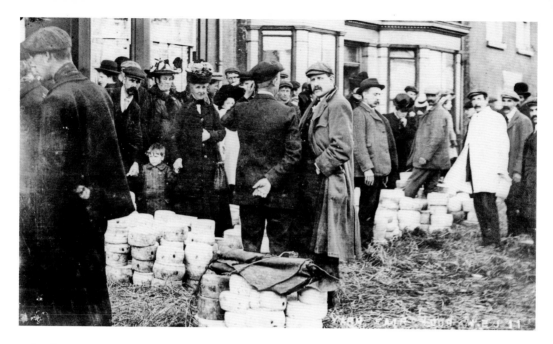

Sale of Cheeses and Local Transport, Yarm Fair

A wonderfully evocative postcard of Yarm Fair. One of its main roles was as a major cheese fair, to which farmers brought their produce from the Yorkshire Dales and the North Yorkshire Moors. Some of the cheeses are displayed here on straw bedding on the High Street in October 1909. For many generations, more than 100 tons of cheese was sold each year in this way. Another form of transport, an Imperial Tramways Bus Company vehicle, is pictured in Yarm High Street outside the Cross Keys Inn (which would be the terminus). This bus was used on the 'Yarm, Eaglescliffe, Stockton' route. The 'Bristol' manufactured bus has solid tyres, and there is a young boy as conductor. The image dates from around 1913.

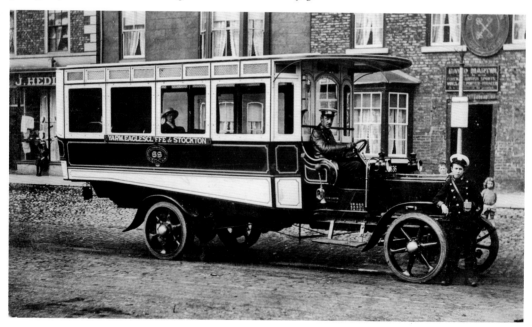

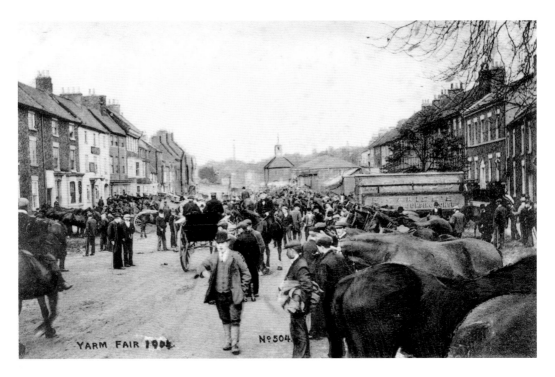

The Horse and Cattle Markets, Yarm Fair

Two early postcards by Brittain & Wright show scenes from the horse and cattle markets at Yarm Fair in 1904, one looking north and the other southwards. Some of the gypsy caravans can be seen in the background, and the cobbled area was obviously substantial. Imagine the exciting atmosphere with the street full of livestock!

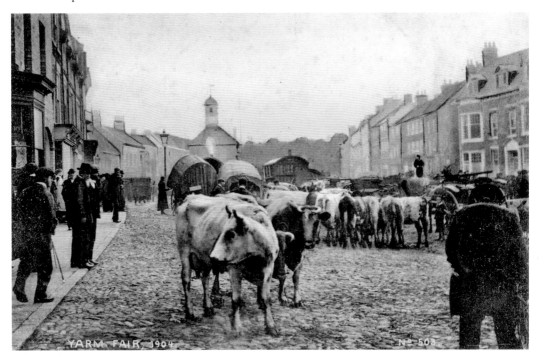

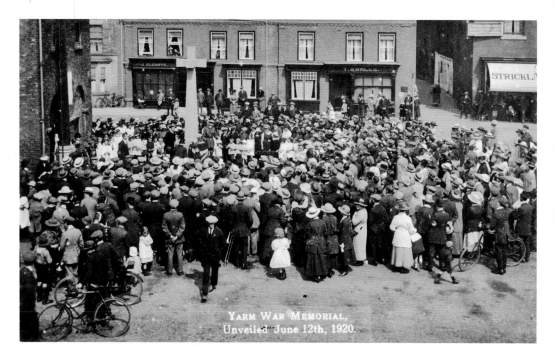

Yarm War Memorial, Unveiled June 12th, 1920.

Yarm War Memorial

This view captures a moment of both sadness and anger, when the First World War memorial was unveiled in Yarm High Street next to the town hall on 12 June 1920. What was meant to be a sombre remembrance ceremony was overshadowed by the unusual design of the cross head, with four horizontal shafts instead of the usual two. This was not allowed to prevail and a more conventional cross shape was installed after a short period. The familiar premises of Strickland & Holt chemist's can be seen on the right.

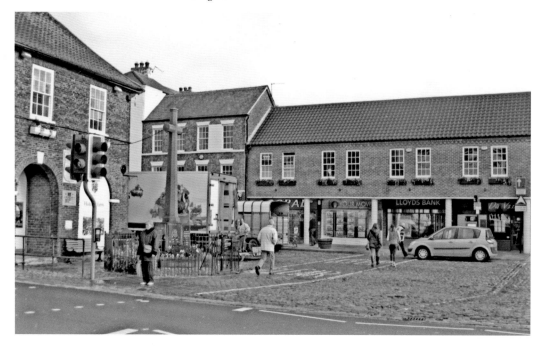

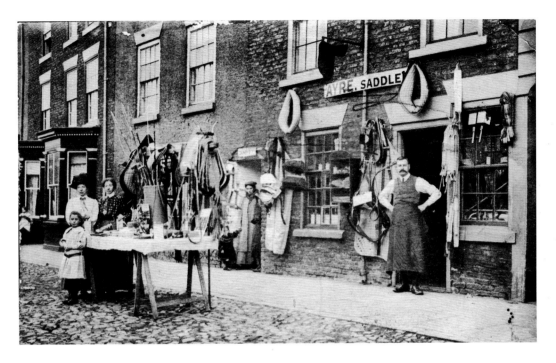

Yarm, the Saddler's Shop

Taken around 1905, the postcard shows a proud John Martin Ayre outside his saddler's shop in Yarm High Street. Pieces of horse harness and carriage lamps hang on the shopfront. The entrance to Danby Yard lies behind the table, where a lady and small child stand. This shop building was replaced later by a modern construction housing an estate agency. The High Street is a very vibrant and colourful scene today, suggesting prosperity.

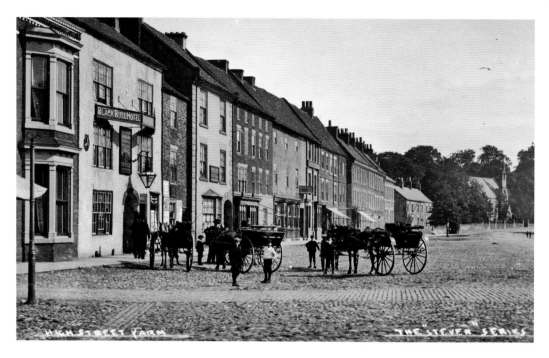

Early Postcard Scenes by Stevens of Thirsk, Yarm

A prolific photographer of local postcard views, the firm of Stevens of Thirsk usually included people, especially children, in their compositions. Here we see pony traps drawn up outside the Black Bull Hotel on the east side of Yarm High Street, with some small children adding interest. Another view is at the north end of the High Street, with No. 124 on the left close to the historic bridge. We can see ladies in long dresses and two gentlemen walking with their bicycles.

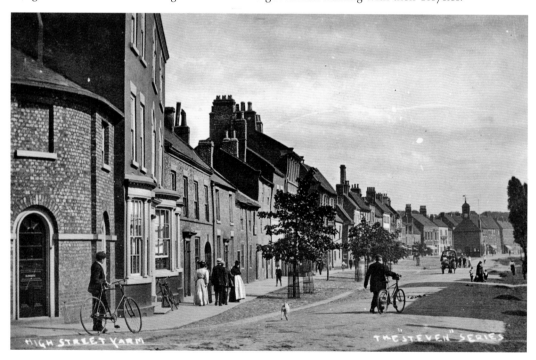

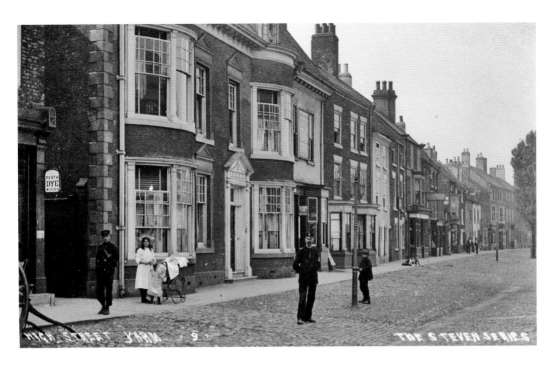

Yarm High Street

Another Stevens postcard of Yarm High Street, with a young girl in charge of both a toddler and a baby in an early pram. The photographer has also captured a postman on the left and a policeman in the centre. One wonders how long he had to wait to achieve all this. Today, Yarm High Street is very fashionable, with smart boutiques and designer labels everywhere, as well as excellent restaurants and other evening venues. The same impressive building in the foreground is now the attractive offices of a firm of well-known local solicitors.

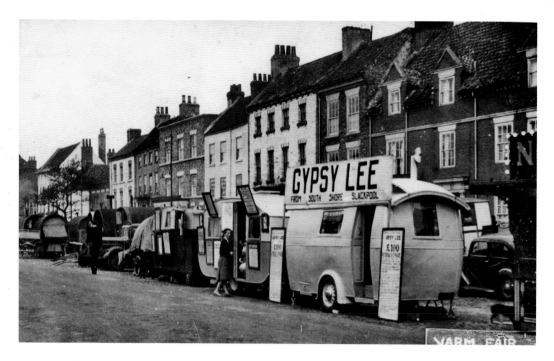

Fortune Tellers, Yarm

Still a feature of the modern-day Yarm Fair, the Romany gypsy ladies advertise their clairvoyant powers in order to attract those worrying about their future romances. There has never seemed to be a shortage of customers throughout the generations. The simple caravans seen here are from the late 1940s, and some of the very traditional 'vardos' can be seen on the left in the distance. From the same vantage point today, the parked cars have taken over from the caravans for most of the year, but the glittering modern caravans will be back in October.

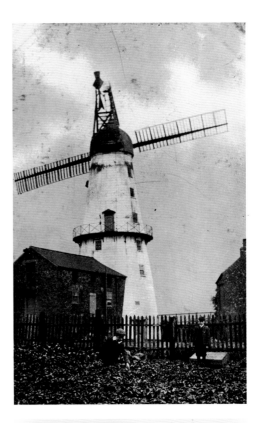

The Mount Pleasant Windmill, Heavisides Printing

A fine Heavisides view of the Mount Pleasant windmill, which stood to the east of Norton Road, near the present Windmill Terrace and Mount Pleasant Road. Built before 1785, it was seven storeys high and probably complete as late as 1920. The work of Michael Heavisides is well represented in this selection. His guide books, almanacs and postcards have been an important contribution to the local history of Stockton and the surrounding district.

Three generations of a local printing firm.

It was in 1777 that Michael Heavisides, in the town of Darlington, printed on a wooden press by the aid of pelt balls.

In 1856, Henry Heavisides, his son, commenced business in Stockton and printed on an iron press using revolving rollers for inking.

In 1870, Michael Heavisides, his son, continued the old business, using cylinder & platen machines, gas engine, stereotyping and other modern appliances.

M. HEAVISIDES.

HEAVISIDES & SON,

4, Finkle Street, Stockton-on-Tees,

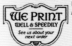

Entirely devote the whole of their attention to the production of Letterpress

PRINTING

From a small Handbill to the largest Poster. NOTHING comes wrong to them in the shape of printing.

The Printing of fine Process Blocks a speciality.

A TRIAL RESPECTFULLY SOLICITED.

The business is under the immediate supervision of M. Heavisides.

HEAVISIDES & SON are the publishers of

"Rambles in Cleveland,"	6d., post free 8½d.	
"Rambles around Osmotherley"	3d., " 4d.	
"Rambles by the River Tees"	8d., " 10½d.	
"The History of the First Public Railway"	6d., cloth 1/-	
"In and around Picturesque Norton"	3d.	
"The True History of the Lucifer Match"	2d.	

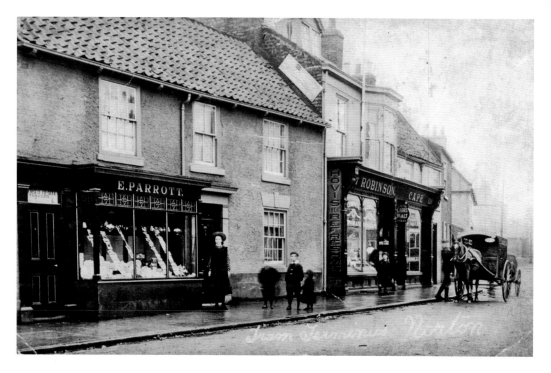

Norton Village

Robinson's Café on the right was also a confectioner, at No. 127 High Street, Norton, up towards the tram terminus by the Green. Parrotts appears to be a tobacco and general goods shop. The advertising postcard was sent in March 1906, from a business in Stockton to a customer near Castle Eden. The bullock in question looks decidedly gloomy about his future prospects.

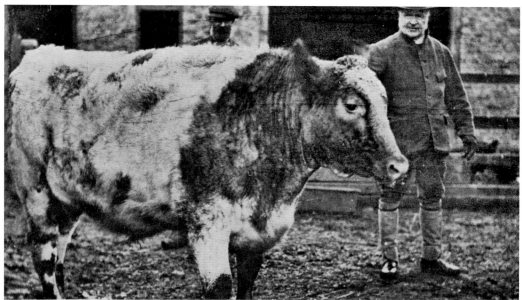

Photo.] [Kipling.
Cross-bred 18 months old "Bibby" Cake Fed Bullock, the property of our esteemed
customer Mr. W. Armstrong, Butcher & Farmer, Norton, Stockton-on-Tees.
Weighed 70 Stones at Christmas, 1905.

Arrival of the Electric Tram System

Laying the new tramlines in 1898 at the top of Norton High Street, outside the Unicorn Hotel. The earlier steam trams had used a 4-foot gauge, and were withdrawn on Christmas Eve 1897. The new electric trams operated on a 3-foot 7-inch gauge, so a major, labour-intensive replacement programme was required for the whole system. The new tram service through to North Ormesby began on 16 July 1898.

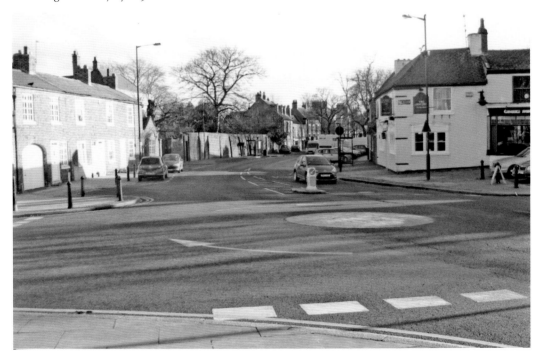

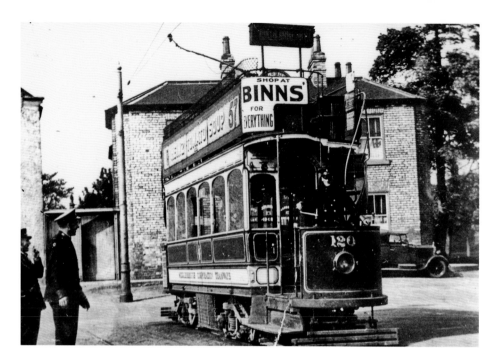

Tram Terminus, Norton Green

The electric trams were very popular as a means of travel into Stockton, Thornaby or Middlesbrough. They were cheap and efficient in an age where bicycles were the most that many families could perhaps afford. These views are both at the 'Clock Building' at the tram terminus at Norton Green. The drivers had to endure all kinds of weather, as did the upstairs passengers. The electric trams only operated in Teesside until 1931.

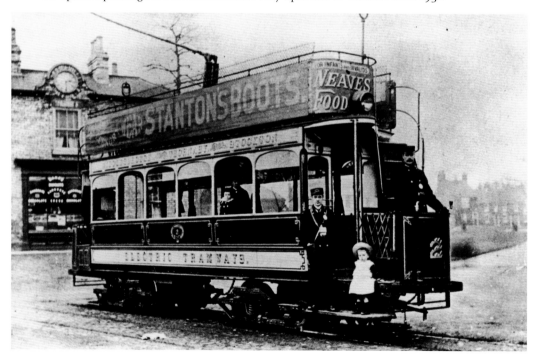

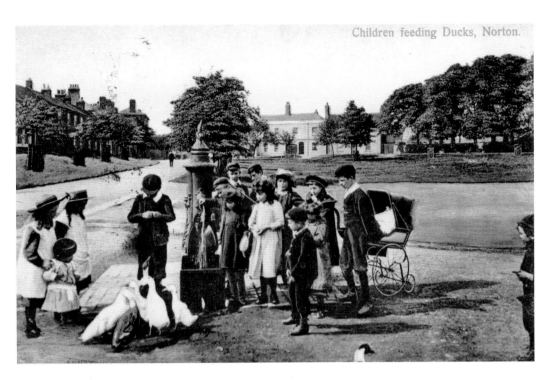

Children Feeding Ducks, Norton Green

A charming 'Armstrong' postcard study of children by the pond on Norton Green in the summer of 1906. One of the village water pumps can be seen in the centre. The mode of dress and the design of the pram add to the historic interest of this scene. The ducks and their new friends, the seagulls, are still there today, and the children and their parents continue to enjoy feeding them.

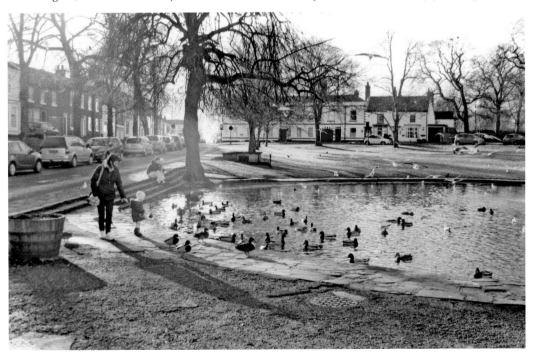

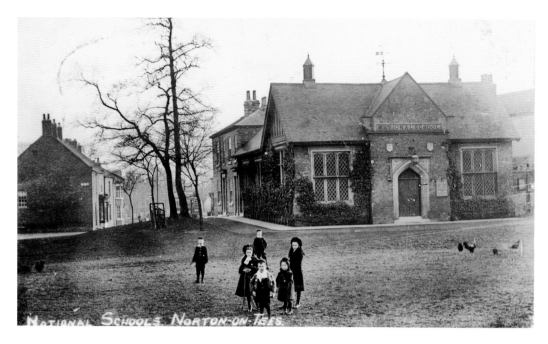

NATIONAL SCHOOLS, NORTON-ON-TEES.

The Local Schools

Two postcard views of the Victorian school buildings in the Norton High Street area, with the children providing some valuable human interest to the composition. The architecture of the National Schools building on the Green suggests it was much older than the boys' school (Norton Board School, 1872), now the site of a large supermarket near the bottom of the High Street. Both postcards were sent to Miss Alice Brittain at No. 145 Piccadilly, London, around 1905. One wonders whether she was a relative of the Brittain & Wright firm in Stockton, and how her smart address can be explained.

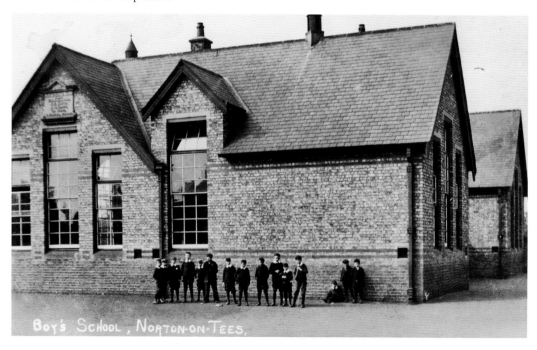

BOY'S SCHOOL, NORTON-ON-TEES,

Diamond Jubilee Cross, Norton

This tall commemorative cross, with its attractive Celtic carving and lettering, was erected in 1897 by the loyal inhabitants of Norton to mark the Diamond Jubilee of Queen Victoria. Unusually, it is not a memorial cross. Taken in around 1907, the children watch the photographer. Today much of the beautiful, detailed carving has sadly been eroded by the weather over the past century.

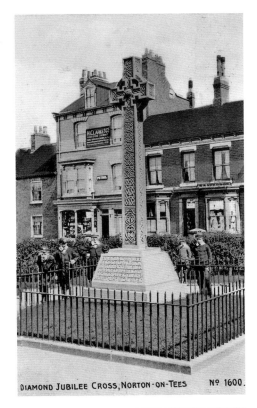

DIAMOND JUBILEE CROSS, NORTON-ON-TEES Nº 1600.

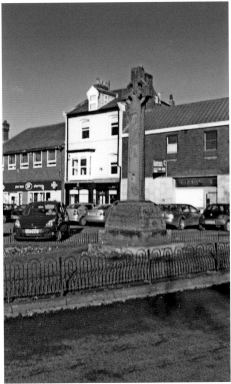

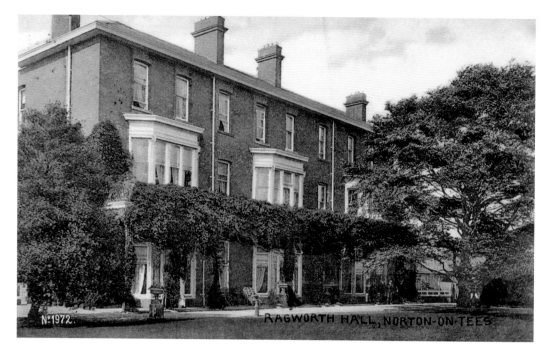

Ragworth Hall

A grand residence that stood on West Row not far from Norton Green, Ragworth Hall has long been demolished. In 1899, its owner was Maj. Robert Irvine but, by 1907, when this postcard was date stamped, it was occupied by Mr John Ropner of the shipbuilding company. This was another postcard sent to Miss Alice Brittain in London. The nearby Norton High Street still has many attractive properties.

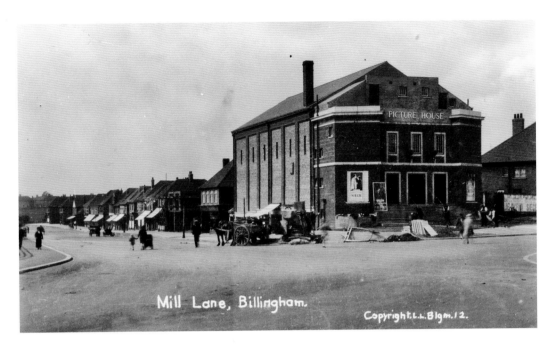

Mill Lane, Billingham.

Copyright.L.L.Blgm.12.

Mill Lane, Billingham

An interesting view of Mill Lane, Billingham, with the Picture House featured prominently. It opened on 8 October 1928, at a construction cost of £10,000, and could accommodate an audience of around 700. In this postcard from around that time, it appears that workmen are completing the pavement area in front of the building with stone flags. Many of the shops further down Mill Lane have their sunblinds in place. The building still stands today, no longer a cinema but housing a number of local businesses as well as offering an events venue with catering.

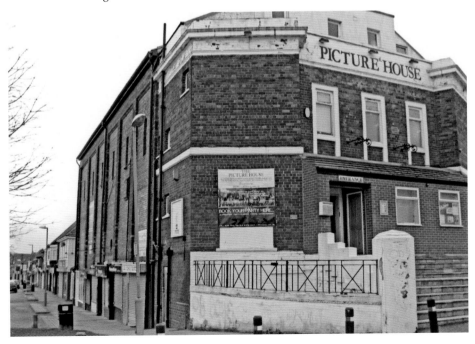

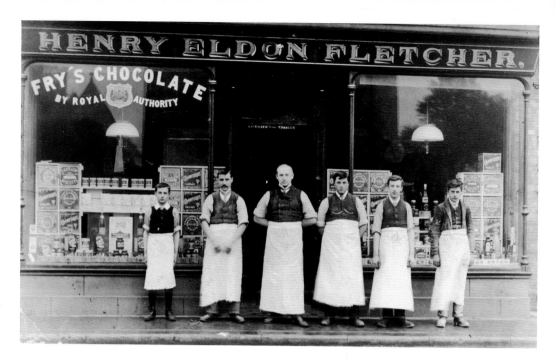

A Famous Billingham Family

Originally the 'Billingham Cash Trading Stores' on Billingham Green, the grocer and provision merchant premises of Henry Eldon Fletcher were rebuilt in 1903. Mr Fletcher delivered his groceries to a wide area, including the local villages, originally by horse and cart, and later by an interesting selection of motor vehicles. The Fletcher family sold the business in 1947, and the premises seen here were demolished in 1963. One of the nearby premises, The Salutation public house, still stands today and has evidently been well looked after during its long life.

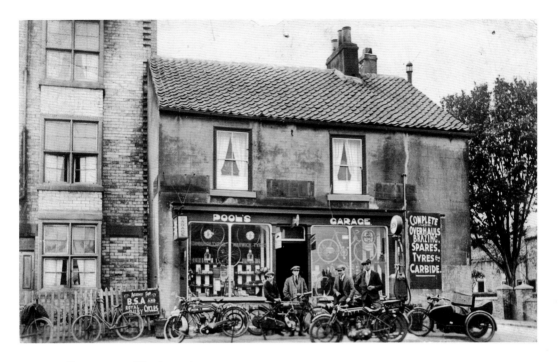

Pool's Garage, Billingham Green

In the 1920s, Charles Pool operated a maintenance garage at the top of Billingham Bank, but his shop on the Green sold motorcycles, bicycles, spares, petrol and oil. A Pratts petrol pump can be seen here on the right, along with an interesting array of early motorcycles and a solitary lady's bicycle next to a sign 'Agent for BSA and Royal Ruby Cycles'. Known as Church View, the property stood next to a very tall, strange building called Tower House. Both were demolished in 1963, leaving this open view.

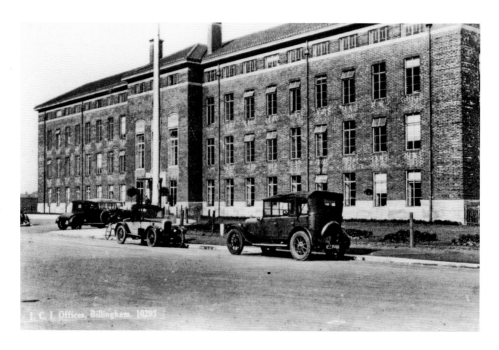

Imperial Chemical Industries Ltd at Billingham

Although ICI was created nationally in 1926 from four major industrial British enterprises, work had begun in 1919 to develop a major chemical works on open farmland close to the historic Billingham village. The first offices were in the centre of the site at the Grange farmhouse, but this new impressive office building was opened on Chiltons Avenue in 1927. It can also be partly seen on the left-hand edge of the other postcard view. The building was camouflage-painted during the Second World War. With the loss of ICI as a trading company more than a decade ago, the office building was demolished, although successor businesses still operate on the main factory site today.

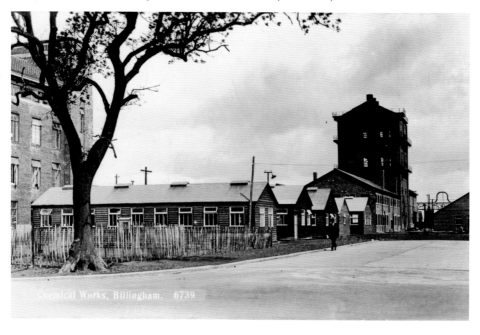

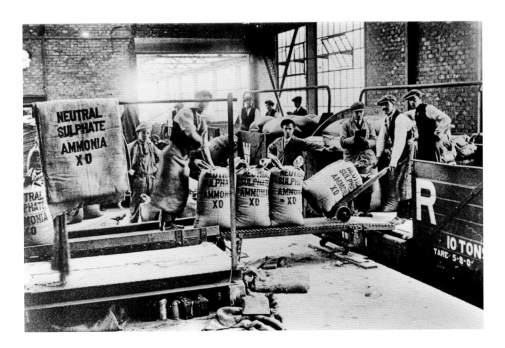

Life in the ICI Factory

At its peak in the 1960s, more than 16,000 employees worked for ICI on the Billingham site. In Teesside as a whole, 20 per cent of all employees then worked for ICI. Virtually every service required was provided by its own direct labour, very different from modern thinking. Agricultural fertilisers were a major product for national and international consumption. Here we see ammonium sulphate fertiliser in jute sacks being loaded onto rail wagons in around 1930. In later years, such operations were amazingly modernised through clever technology. A favourite escape route over the years for ICI employees was the ICI Billingham Synthonia Club, hit by a bomb in the Second World War but still serving pints today.

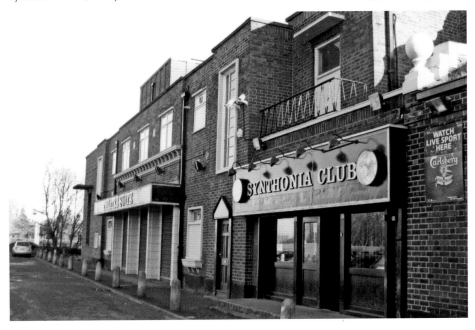

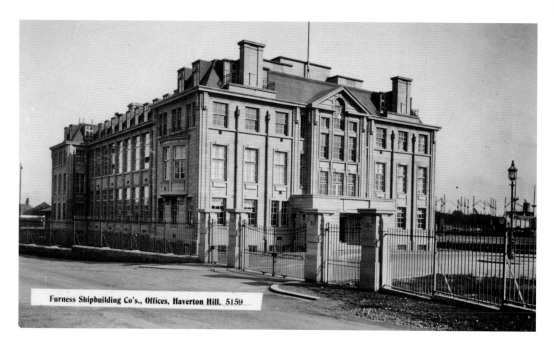

Furness Shipbuilding Co's., Offices, Haverton Hill. 5159

Furness Shipbuilding Company Ltd

The imposing offices of the Furness Shipbuilding Company at Haverton Hill. The yard owed its origins to the urgent national need to replace cargo shipping sunk by German submarines during the First World War, construction work commencing in 1917. In the early period, many of the skilled and heavy jobs were undertaken by women because the great majority of local men were away at war in Europe. The shipyard closed more than thirty years ago, and this impressive building was then demolished. Some of the large sheds on the site have survived and are being used by other companies.

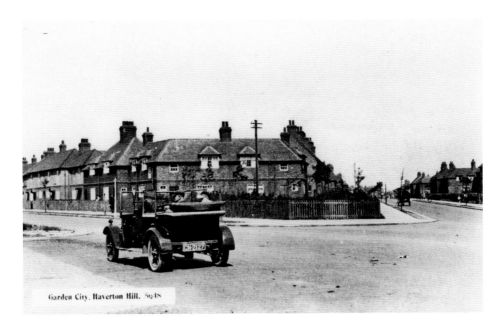

Garden City, Haverton Hill. 5948

Workers' Housing Provision

In common with some other big employers, the Furness Shipbuilding Company could not find enough skilled local labour for their needs, and had to recruit further afield. This also meant that they had to enter the field of social housing provision, a policy earlier adopted elsewhere in the country by the Quaker firms of Rowntree's and Cadbury's, and also by Lever Brothers at Port Sunlight. Belasis Garden City was constructed around 1920, and here Belasis Avenue lies to the left with St Vincent Street to the right. The estate eventually suffered badly from aerial pollution, and was demolished in the 1960s and '70s. Locally in Billingham and Norton, ICI built more than 1,800 similar houses, some of them seen here today. They are now usually owned by the occupiers.

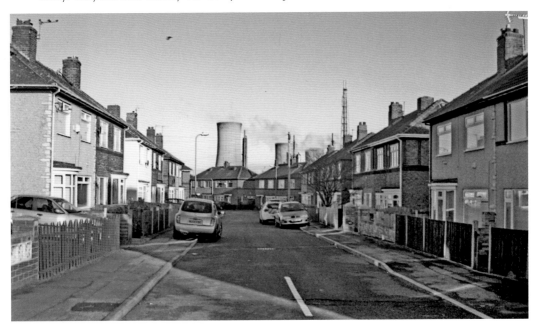

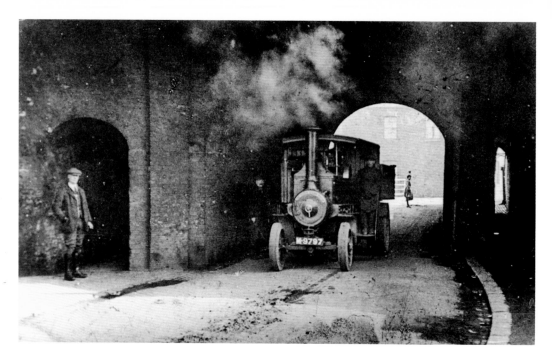

The Age of Steam, Haverton Hill

An evocative and interesting view of a steam wagon passing through the old railway bridge at Haverton Hill station, heading for Stockton in March 1919. The bridge was later replaced with a more convenient one in the light of significant traffic growth. These arches were well remembered by the older generations as being the scene of the murder of a travelling pedlar by some of the village boys in the early part of the last century. Today's view conveys nothing of this history and atmosphere.

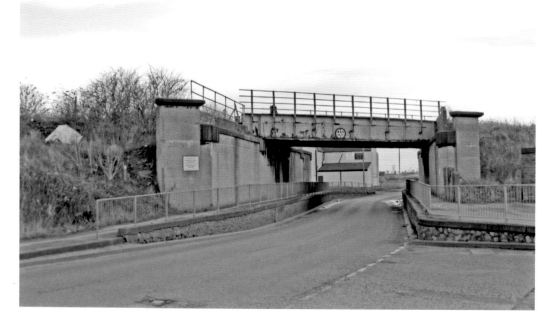

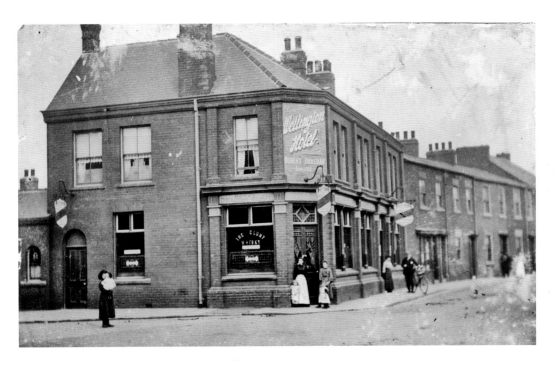

Wellington Hotel, Haverton Hill

A postcard sent at Christmas in 1905 by the Young family (landlords of the Wellington Hotel, seen here in Clarence Street, Haverton Hill) to a young lady at the address of a butcher's shop in Thornaby. At that time, local competition for the Wellington came from the Queen's Head Inn and the Haverton Hill Hotel. Also taken in Clarence Street, some local shops pictured include a men's outfitters, J. Levy, with the brine well derricks and chimneys of Tennant's Salt Works just visible in the distance.

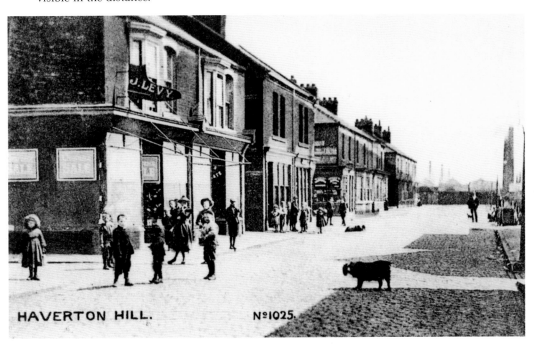

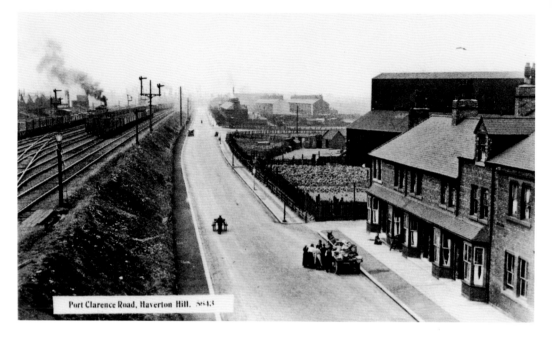

Port Clarence Road, Haverton Hill. 86.1.3

Port Clarence

An early postcard of Port Clarence, near to the northern end of the Transporter Bridge. The impressive railway system on the raised bank to the left disappeared long ago, to be replaced by giant sheds for North Sea development projects. Very little of this scene remains, with the exception of the Clarence Station Hotel building on the far right, now known simply as the Station Hotel. The bay-windowed houses next to it were called Crosby Terrace, and a rag-and-bone man with a horse and cart is seen talking with the local housewives in the street. From a similar date, we have a rare postcard view of the staff at Port Clarence railway station, next to an early locomotive engine. No doubt it was a busy station so long ago, with all those staff!

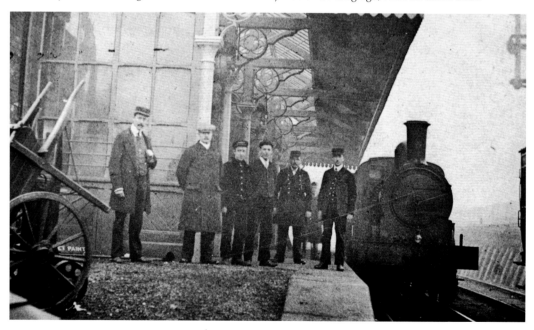